Translated from the French
by Christine Donougher

The Book of Tobias

Sylvie Germain

Dedalus

Funded by
THE
ARTS
COUNCIL
OF ENGLAND

Dedalus would like to thank The Arts Council of England, The Burgess programme of The French Ministry of Foreign Affairs and The French Ministry of Culture in Paris for their assistance in producing this book.

Published in the UK by Dedalus Ltd, Langford Lodge, St Judith's Lane, Sawtry, Cambs, PE17 5XE email: DedalusLimited@compuserve.com

ISBN 1 873982 39 9

Dedalus is distributed in Australia & New Zealand by Peribo Pty Ltd, 58 Beaumont Road, Mount Kuring-gai, N.S.W. 2080

Dedalus is distributed in Canada by Marginal Distribution, Unit 102, 277 George Street North, Peterborough, Ontario, KJ9 3G9

Dedalus is distributed in Italy by Apeiron Editoria & Distribuzione Localita Pantano, 00060 Sant'Oreste (Roma)

First published by Dedalus in 2000
First published in France in 1999

Tobie des Marais copyright © Editions Gallimard 1998
The translation of The Book of Tobias copyright © Christine Donougher 2000

The right of Sylvie Germain to be identified as the author and Christine Donougher to be identified as the translator of this work has been asserted by them in accordance with the Copyright, Design and Patents Act, 1988

Typeset by RefineCatch Ltd, Bungay, Suffolk
Printed in Finland by Wsoy

A C.I.P. listing for this book is available on request.

institut français

French Literature from Dedalus

French Language Literature in translation is an important part of Dedalus's list, with French being the language *par excellence* of literary fantasy.

Séraphita – Balzac £6.99
The Quest of the Absolute – Balzac £6.99
The Experience of the Night – Marcel Béalu £8.99
Episodes of Vathek – Beckford £6.99
The Devil in Love – Jacques Cazotte £5.99
Les Diaboliques – Barbey D'Aurevilly £7.99
The Man in Flames (L'homme encendie) – Serge Filippini £10.99
Spirite (and Coffee Pot) – Théophile Gautier £6.99
Angels of Perversity – Remy de Gourmont £6.99
The Book of Nights – Sylvie Germain £8.99
The Book of Tobias – Sylvie Germain £7.99
Night of Amber – Sylvie Germain £8.99
Days of Anger – Sylvie Germain £8.99
The Medusa Child – Sylvie Germain £8.99
The Weeping Woman – Sylvie Germain £6.99
Infinite Possibilities – Sylvie Germain £8.99
Là-Bas – J. K. Huysmans £7.99
En Route – J. K. Huysmans £7.99
The Cathedral – J. K. Huysmans £7.99
The Oblate of St Benedict – J. K. Huysmans £7.99
The Mystery of the Yellow Room – Gaston Leroux £7.99
The Perfume of the Lady in Black – Gaston Leroux £8.99
Monsieur de Phocas – Jean Lorrain £8.99
The Woman and the Puppet (La femme et le pantin) – Pierre Louÿs £6.99

Portrait of an Englishman in his Chateau – Pieyre de Mandiargues £7.99
Abbé Jules – Octave Mirbeau £8.99
Le Calvaire – Octave Mirbeau £7.99
Sébastien Roch – Octave Mirbeau £9.99
Torture Garden – Octave Mirbeau £7.99
Smarra & Trilby – Charles Nodier £6.99
Tales from the Saragossa Manuscript – Jan Potocki £5.99
Monsieur Venus – Rachilde £6.99
The Marquise de Sade – Rachilde £8.99
Enigma – Rezvani £8.99
The Wandering Jew – Eugene Sue £10.99
Micromegas – Voltaire £4.95

Forthcoming titles include:

L'Eclat du sel – Sylvie Germain £8.99

Anthologies featuring French Literature in translation:

The Dedalus Book of French Horror: the 19c – ed T. Hale £9.99
The Dedalus Book of Decadence – ed Brian Stableford £7.99
The Second Dedalus Book of Decadence – ed Brian Stableford £8.99
The Dedalus Book of Surrealism – ed Michael Richardson £9.99
Myth of the World: Surrealism 2 – ed Michael Richardson £9.99
The Dedalus Book of Medieval Literature – ed Brian Murdoch £9.99
The Dedalus Book of Sexual Ambiguity – ed Emma Wilson £8.99
The Decadent Cookbook – Medlar Lucan & Durian Gray £8.99
The Decadent Gardener – Medlar Lucan & Durian Gray £9.99

THE AUTHOR

Sylvie Germain was born in Châteauroux in Central France, in 1954. She read philosophy at the Sorbonne, being awarded a doctorate. From 1987 until the summer of 1993 she taught philosophy at the French School in Prague. She now lives in Paris.

Sylvie Germain is the author of nine novels, a study of the painter Vermeer and a religious meditation. Her work has so far been translated into seventeen languages.

THE TRANSLATOR

Christine Donougher was born in England in 1954. She read English and French at Cambridge and after a career in publishing, is now a freelance translator and editor.

Her many translations from French and Italian include Sylvie Germain's *Days of Anger* and *Night of Amber* and Giovanni Verga's *Sparrow*.

Her translation of Sylvie Germain's *The Book of Nights* won the T.L.S. Scott Moncrieff Prize for the best translation of a Twentieth Century French Novel during 1992.

Also available by Sylvie Germain:

The Book of Nights

Night of Amber

Days of Anger

The Medusa Child

The Weeping Woman on the Streets of Prague

Infinite Possibilities

CONTENTS

THE FUGITIVE

When I reached manhood, I married Anna, a
woman of our own lineage. By her I had a son
whom I named Tobiah.

The Book of Tobit 1: 9

Suddenly, the sky was made mineral, changed into dark blue slate. And above that land devoid of all relief, overwhelmed with silence, the sky was vast. A wall of slate, at the foot of which rose the slender silhouettes of poplars shivering silverly. Likewise did the animals in field and farmyard stand trembling and immobile. The wall thundered, like a gong of doom. Then the slate turned to purple-black, before being rent open. Torrential rain assaulted the earth. Visibility dropped to zero. The driver at the wheel of his car lashed by the rain felt as if he had been transformed into a diver. He slowed down, and switched on the windscreen wipers. Within the fleetingly drawn arc on his windscreen he glimpsed a strange meteorite rushing straight towards him. The surrounding void was surely in the grip of a mood of whimsy. A small golden-yellow globe mounted on a wheel – as if the sun had been sent plummeting down to earth by the violence of the storm and had been drastically reduced in its fall to the absurd dimensions of a bright-yellow pumpkin – was speeding along this country lane. But the vision of this miniature sun toppled from the firmament lasted only an instant. The windscreen was immediately covered again with a veil of streaming grey. And at brief intervals the driver caught further glimpses of that extraordinary image. He blinked, his brow straining towards the windscreen. The beating rain came down so hard, so violently, that it drowned out the music from the radio. The man automatically turned up the volume, and a mournful voice, soon joined by another voice, and then another, slow and deep in modulation, filled the diving bell. '*Nantu'un lettu di filetta/stese sott'à lu castagnu/ l'anime di sti circondi/ci ghjocanu cù lu mondu . . .*[1]'

[1] Lying beneath the chestnut tree on a bed of ferns, the spirits of this place toy with the world . . .

The passenger seated beside the driver gave a long gentle sigh, like a man emerging from a daydream, or one who has just reached the confines of an idea too far-reaching to be pursued.

'Ah, you're awake!' said nervously the man who remained tensed at the wheel.

'I wasn't asleep,' said the other.

'So you saw that thing on the road there ahead of us, veering from side to side?'

'I did.'

'What on earth can it be?' the driver insisted.

'Best thing's to stop,' suggested the passenger by way of reply.

'*Balla mondu/gira mondu* . . .'[2] the Corsican voices sang.

The car braked slowly and came to a halt at the side of the road. The passenger opened the door.

'You're going out in this downpour!' exclaimed the driver.

A deeper voice sang the second couplet of the song, an expansive voice that sounded as if it issued from a parched mouth of red-brown and ochre earth, a fire-seared mouth, from a throat vibrating to the rhythm of the winds and the sea. The passenger merely smiled, then closed the door behind him and walked off into the rain. '*Balla mondu/gira mondu* . . .' came the final refrain of the polyphonic song.

The stranger soon came back, drenched.

'Well?' said the driver, turning off the radio and eyeing with disapproval his dripping-wet passenger to whom he had given a lift a little earlier, under the impression, because of those flowing locks of shoulder-length light-brown hair, that the person he had seen hitch-hiking in the middle of the country-side with a storm threatening, was a young girl. And he still remained uncertain for a while as to the identity of his passenger, whose appearance – and even whose voice, that

[2] The world dances, the world turns . . .

slightly husky, melodious voice – was such a blend of masculine and feminine. But the hitch-hiker spoke very little, giving only short evasive answers to the questions the other asked, and the conversation soon died. 'Sir takes me for his chauffeur,' the driver inwardly fumed, and that is how he came to the conclusion that his passenger was a young man.

'Well?' he said again, irritated by the offhandedness of this pseudo-androgyne who was in no hurry to convey what he had seen, and was nonchalantly shaking his misleadingly beautiful – and, what was more, thoroughly wet – hair.

'It was a small child zigzagging across the road,' he said at last. 'He's already cycled past us and gone speeding off in the opposite direction. We'll have to turn back.'

'In this filthy weather!' the driver grumbled. But at that moment the rain stopped as suddenly as it had started, and the sky took on the appearance of gleaming clay.

'You see,' said the young man, 'the weather's brightening . . .'

The car restarted, turned round, and crawled forward. The little bright-yellow meteorite soon appeared, travelling right down the middle of the road, accompanied by sprays of water rising to shoulder height.

'That crazy kid's going to get himself killed!' exclaimed the driver, slightly accelerating and keeping as far over to the right as possible. As soon as the car came near, the child abruptly wrenched round the handlebars of his tricycle and went zooming off the other way at top speed.

'The little brat!'

The passenger burst out laughing.

'You find that funny, do you?' said the other, enraged.

'Of course. Just look at the little savage: yellow oilskin, bright-green plastic tomahawk slung across his back, pedalling that red tricycle with all his might. What a bold sense of colour, and what energy! Don't you find him endearing?'

'A damned nuisance, I'd say!'

'Not at all. Just a child, as light as a wisp of hay, caught up in some violent grief.'

'What a load of rubbish!' snorted the driver, shrugging his shoulders.

The car reversed to catch up with the tiny three-wheeled meteorite. The child tried once again to get away, but the driver, exasperated by this absurd chase, braked suddenly and leapt out of his vehicle. He rushed towards the kid and grabbed him by the collar of his oilskin.

'That's enough of your nonsense!' shouted the man, lifting up the unruly child, but the boy clung to his handlebars, kicking out in all directions. The man forced him to let go and dragged him to the roadside.

'What do you think you're doing?' he said, panting for breath. 'You want to get yourself run over, you idiot?'

'I don't care!' the youngster muttered. His oilskin was buttoned up all crookedly and his hood came right down over his eyes. Very big, beautiful, black eyes, gleaming with tears.

The man suddenly felt his anger melt away. He crouched down in front of the child, slightly loosening his grip, and asked him, 'Now where do you think you're going?'

The child gave a start, raised his head, and with those glistening eyes held the man's gaze, 'I'm going to the devil!'

Now it was the driver who almost burst out laughing, but there was such seriousness and despair in this little boy whose irregular thumping heartbeat he could hear, that he dared not say anything for a moment. Then he recovered himself, 'The devil! But how do you know where he lives?'

And the reply came back with terrible finality. 'Yes, straight ahead. That's where my father sent me.'

'Now, you're talking nonsense,' said the man in a voice that tried to sound reassuring. 'First of all, the devil doesn't exist and, more important, your parents must be worried . . .'

The child cut him short. 'Yes, the devil does exist! He even

stole my mother's head, he did, and my father chased me away, waving his arm like a sword, just so.' And he brandished his own arm in the air.

The man could not make much sense of this, except that some tragedy, a crime perhaps, must have occurred.

The younger man was standing close by, observing this scene in silence. When the little boy extended his arm in imitation of his father's gesture, he caught his hand, gently, in mid air, and held it in his own. The child glanced at him with fury in his eyes, but his fury soon calmed.

'You've no business with the devil,' the young man said with quiet gravity, 'nor has he any business with you. Your father, on the other hand, needs you very much. You must go back to him. Come along.'

The child remained uncertain, his fear and anger gone, like a fever that, after a violent bout, suddenly passes, leaving its victim in a state of terrible weakness. He swayed slightly, so the young man picked him up in his arms and carried him to the car.

'Bring the tricycle,' he said to the increasingly disconcerted man, 'we're going to drive this boy home.'

The other obeyed, and put the tricycle in the boot of the car, but once he was behind the wheel again he protested, 'We don't even know where the kid lives, and besides, from what he's said, it would surely be better to go to the police . . .'

'I know where he lives, I'll tell you the way. It's not very far.'

'Oh, so you're from these parts?'

'Not really, but the main thing is that I can direct you.'

'But look here,' said the driver, unnerved by the whole business, 'don't you think we should . . .'

'Take the child home as quickly as possible, yes!' said the young man, with the boy on his lap, brooking no further discussion.

And the car set off once more on the road through the

fens. A kite rose up from a ditch, its flight slow and heavy. The road, covered with large puddles of water in which was reflected the now indigo sky, was shimmering blue. The driver felt as if he were driving in a completely unknown land that was almost unreal, where the elements mingled together in an alchemy of light. The child fell asleep, tired out and exhausted by his tears, his head resting in the crook of the young man's elbow, while the latter quietly gave the driver directions.

The father meanwhile was ranging the countryside, striding up and down paths, rummaging in ditches and bushes. He paid no heed to the brambles or barbed wire that tore his jacket and scratched his hands. And he cried, 'Anna! Anna!' He called his wife, he called her insanely . . . really insanely, since she had just died and her body was lying back there, at the house. Well, it would not be quite accurate to say it was lying, because her husband had seated the dead woman in the big mahogany armchair upholstered in lime-green velvet that stood in the drawing room by the fireplace. The dog Onyx had settled at her mistress's feet and would not stop whining.

But this body was incomplete, indeed it was missing the most important thing: its head. And it was this head that Theodore sought in thicket and undergrowth, everywhere. And that is why he called his wife: that her mouth might speak and she might answer, 'Here I am.'

When reality itself breaches its barriers, when it ruptures without warning, allowing some terrible, blinding vision to manifest itself, it is natural that a man should then lose his sense of reality and stand teetering for a moment on the brink of madness.

Well, the vision that had invaded the Lebons' farmyard, where Basalt the peacock, with his feathers of midnight blue, was strutting about in the company of a black hen, a vision

made all too much of flesh and reality, was of a kind to set a man's heart and mind reeling.

For early that afternoon, as Theodore was emerging from his house, singing under his breath the refrain of an old song learned in childhood, which he had never tired of since: 'Tschiribi, tschiribi, tschiribi bom bom bom, tschiribom – oy, tschiribi biri bom . . . ', Obsidian the mare ambled into the farmyard, carrying on her back her decapitated rider, whose shoulders were soaked with blood. Theodore's voice dried, although his lips continued to move for a few moments, mouthing an inaudible 'tschiribi bom bom'. This apparition could not be real, the reflections of light must be playing tricks on him. The light in the fenlands is always so unsettling, you can never tell whether it emanates from sky or earth, trees or water.

Theodore tried to catch his breath, but failed. His breathing was suspended, like the words of the song, like time. Obsidian came to a halt by the stone wall bordered with hollyhocks and Theodore saw magnificent clusters of white flowers fringed with scarlet emerging from his wife's neck: Anna's face had turned into a snowy-white bouquet. A hollyhock woman.

But the mare snorted, and her fantastical rider lost her balance, tipping over to the left and sliding out of the saddle. Since her feet were still caught in the stirrups, she dropped down the side of her mount, while the tall flowering stems continued to stand upright in front of the wall, gently swaying in the breeze. A dark red puddle was extending on the gravel, like the corolla of a splendid flower blossoming open. Theodore moved forward like a sleepwalker, his feet no longer treading the earth, the world slipping away from him. He went up to the mare who turned her head away unconcerned, and pulled down the body, took it in his arms and carried it into the house. He put it in the drawing room chair, where Anna liked to sit and read in the evenings. He propped her shoulders against the backrest, laid her arms on the arms of the chair, and

folded her legs properly, with her knees set close together. Then he took the big cashmere shawl that covered the sofa and spread it over Anna's lap. He treated the dead woman like a convalescent who had to be protected from the cold. The lime-green velvet of the armchair was soon tinged with crimson; the hollyhock woman just would not stop dispersing her liquid flowers, also scattering a shower of little red petals on the tiled floor.

Theodore's movements were neat and precise, as he busied himself round the headless body like some scrupulous robot; but his sanity was overturned. He did not utter a word. A logic, as rigorous as it was absurd, had just awakened inside him: it was pointless speaking to a headless corpse since it has no ears to hear or mouth to reply, but you could talk to a head, even one without a body, you could ask it questions. And that is why, as soon as he had settled Anna comfortably in the armchair, he went out in search of that missing head.

He double locked the front door. The mare was gone, but he did not notice. The peacock had settled in the shade of a hydrangea bush, while the black hen was hunting for worms in a bed of nasturtiums.

As he staggered across the farmyard he saw his son Tobias appear from nowhere, perched on his red tricycle and whooping war cries inspired by those of the Indians in westerns. He was wearing his yellow hooded oilskin, his mother having thought, from the look of the sky after lunch, that it was going to rain. As soon as he caught sight of his father, the child's warrior enthusiasm redoubled, and his cries grew shrill. Theodore froze. Tobias should not go into the farmyard and see the pool of blood, let alone enter the house. But, incapable of explaining – explaining what, anyway? – he could only emit a roar. The child thought his father was joining in the game, imitating a bear, so he pedalled excitedly, waving his plastic tomahawk. He rode straight into his father's legs and fell over.

It was not funny at all, and certainly somewhat inglorious for a warrior, so he sulked, even verging on tears. He was expecting his father to pick him up, make a fuss of him and start the game off again. He did nothing of the sort. Theodore grabbed him by the shoulders, roughly pulled him to his feet, and in a voice unrecognizable to the child said, 'I forbid you to go into the farmyard, do you hear? I forbid you!'

Tobias looked at him in bewilderment. He heard him, of course, but understood nothing. And he noticed that his father was splattered with blood, his clothes and hands were all stained red with it, and there was something terrifying about his face with its suddenly altered, strained features, and something even more terrifying about the look in his eyes, which were both staring and vacant.

Tobias was seized with panic. He had never seen his father like this before. A huge sob rose in his throat, but so suddenly that it became knotted there, turning into a ball of lead, and choking him. The terror with which Theodore had been stricken since the appearance of the headless rider was passed on to his son. It did not matter that the child knew nothing, he perceived everything with painful acuity; everything – that is to say, the impossible, the unmentionable: the sudden intrusion of disaster.

As his son seemed not to react, but just stood there, staring at him wide-eyed with a look of stupidity and distress, Theodore, feeling himself caught in the spiral of some evil snare, began yelling again, 'I forbid you to enter the house! Go away! Go away!'

But where was a child of only five to go?

Then Tobias, in a plaintive, urgent voice, said, 'Mama.' That wonderful magic word which, whenever Tobias uttered it, was never long in assuming a face and body, smile and scent, and dispensing tenderness and kisses. 'Mama!' Tobias implored for a second time.

Theodore's hands then fastened like claws on the child's

shoulders, and words that he was no longer in control of came pouring from his mouth: 'Your mother's lost her head! Her head's gone, gone! And you can go to the devil!' And he stuck his arm out in front of him, over Tobias. His hand was not pointing in any particular direction, but was trembling with violence.

The child translated these insane words and that commanding gesture into his own language: 'The devil has stolen mama's head and I must go off into the unknown to fetch it.'

He buttoned up his oilskin awry, picked up his tricycle, clambered on to it, and without asking any further instructions headed for that nowhere indicated by his father's hand of authority. Armed with his tomahawk, he would surely be able to force the devil to give him back his mother's head. And so it was that he set off down the road, frightened and angry.

The child pedalled blindly, defying his fear, his tiredness, and soon a rising, gathering wind, and eventually thunder and rain. His father ran along the hedgerows, peered down into the turbid water of the canals, hunting in every direction, and he called, he called till his voice cracked: 'Anna! Anna!' But he did not find his wife's severed head, no more than did his son rout out the devil's lair.

Anna – Theodore had spent nearly fifty years without knowing her, without even suspecting her existence, but from the moment he met her, life without this woman seemed to him inconceivable. And though it was love at first sight, this was not to say that Theodore was inflamed with a burning passion that day. For this man of the fens had no affinity with the dynamics of fire, let alone thunderbolts, storms and lightning. He had the calm, gentleness and secret strength of slow-moving waters, deeply mingled with the earth, clouds and trees, and above all their virtue of silence. So it was, rather, an

inundation of light and exorbitance of space that he experienced when he came upon Anna, and his immense astonishment at the sight of her was at once counterbalanced by a sense of total matter of factness, as if they had both arranged to meet a very long time ago, long before they were born.

The fieriness resided in Anna: a very dense, contained fire, apt to magnify the qualities and powers of water.

Indeed when he first set eyes on her, she had put him in mind of a tall flame enclosed in the lantern of a lighthouse. A lighthouse with a fixed bluish light, shining through the thick fog in a street of Nantes. Theodore had come to this town on business. He was looking for a place to eat before going back to his hotel. The fog not only made the houses, buildings and passers-by indistinct, it also muffled sounds. The town floated in wan and silken obscurity.

The sight of that slender ash-blue figure in the brightly lit telephone booth piercing the fog had been strangely moving. It was like a call to order, for reflection, contemplation, after a day's work; a reminder of the mystery of human nature. And Theodore sensed a whole host of images take shape within him, and unfurl before his wide-open and perfectly wakeful eyes. He beheld a slow-moving flight of dreams pass by in the fog. He approached the magic lantern that afforded this flood of images and emotions. He put his hand to the glass, barely touching it. The woman had her back to him and was unaware of his presence. She was speaking in a rather low voice, too low for Theodore to be able to catch her words. But he did not want to spy on her, he only wanted to brush with his fingertips the bluish substance of the vision by which he had been attracted, enchanted. His hand, as it were, a second gaze.

Without even being conscious of doing so, he read the phone number over the unknown woman's shoulder and memorized it. Still deep in conversation, the woman tilted her head slightly to one side and gave a little laugh. Theodore

then felt ashamed to be watching her like this, without her knowledge. That discreet laughter, not intended for him, made him mindful of his own indiscretion, but he also felt a stab of jealousy. To whom, then, was this gift of her laughter made?

He went away silently, across the road. On the pavement opposite stood another telephone booth. Without further consideration, he went in and dialled the number he had read a moment earlier. The line was of course engaged. He was prepared to wait for hours, all night. He did not have to wait so long, the call came to an end, and the tone on the line immediately changed. With a beating heart, he turned his head towards the lantern-booth: the woman, who was on the point of leaving, was startled, and hesitated before picking up the receiver. Then Theodore started talking, as one might throw oneself into the void. He did not know what he was saying, or where the words came from that he spoke so fluently and with such poetic imagination. Nearly half a century's worth of words, images, thoughts, feelings and dreams were suddenly concentrated in him, distilled to extreme purity – surely under the effect of that blue flame, to have produced such unwonted lyricism.

The woman's initial wariness soon gave way to perplexity, then, perhaps amused by the amazing eloquence of her invisible interlocutor, she was emboldened to respond. The telephone suddenly cut short their long-distance conversation. But it was not such a long distance, only a matter of crossing the road. Which is what Theodore did, and he came and tapped with his fingertips on the glass booth where the woman still stood, holding the receiver in her hand. At last she turned her face to him. A face naked and polished like a narrow oval-shaped mask – her chin was particularly small, and the blackness of her eyes was heightened by the pallor of her complexion. Theodore could not have said whether or not she was beautiful – she was different, to say the least.

At first she gave him a rather brooding look, then a faint smile, and finally, faced with this suddenly tongue-tied man who had been talking in such an inspired way, so lyrically, a few moments earlier, she laughed. This time that husky laugh was intended for him, Theodore, and with the gentle blaze of that laughter Anna invaded his heart, never more to leave it.

Theodore continued on his way through the streets of Nantes with the woman at his side, blue and yielding like a fog-enhancing flame favouring chance and love.

Anna was twenty years younger than him, but this difference in age had proved no more of an obstacle than any of the other differences between them. Their dissimilarities, far from provoking the least discord, bestowed on the couple a subtle harmony. Theirs was a closeness of mind, heart and way of seeing.

While Tobias went tearing off in pursuit of the devil and Theodore roamed the countryside, old Deborah came tottering down the road. She carried a wicker basket, clutched to her stomach. In the basket, wrapped in a white cloth, was a cake she had just taken out of the oven: a lovely, golden apple-cake smelling of sugar and butter and cinnamon. Tobias adored this dessert and it was for him that she had made it.

Deborah was in her nineties, and Tobias was her great-grandson. She acted as his grandmother, her daughter, Theodore's mother, having died many years ago. She had always acted as her family's repository of memory, for both the living and the dead, her own time on earth seemingly without beginning or end.

She caught sight of Anna's black mare in the distance, wandering about in a field. She was surprised to see the mare at loose in a field where she had no business to be, but she continued on her way. In the yard she noticed a big dark red puddle, and thought a bottle of wine must have been broken. She knocked on the door, her knocks dying away in the

emptiness. Since the door was locked, Deborah concluded that everyone was out. Then she walked round to the back of the house. A spare kitchen key was always kept hidden at the bottom of an old iron watering-can, under the porch. So she entered through the back door. She intended just to leave her cake on the kitchen table, where Tobias would find it for his tea – in fact it was nearly tea-time now. But she heard the dog whining: that intense, continuous whimper typical of animals when the smell of death hangs round them. Deborah listened, intrigued, wanting to call the dog but she had forgotten her name. Anna gave her animals bizarre names, the names of rocks and minerals that were impossible to remember. She made her way to the drawing room from where the whining came, her basket still held in front of her, warming her stomach. Because she was looking for the dog, her eyes only searched the room at ground-level, and it was there, on the floor, that she eventually found her. Onyx was lying at her mistress's feet. She did not stir, nor did she stop whining at Deborah's approach. Anna was wearing riding boots, all spattered with mud. The cashmere shawl draped over her lap covered her legs in silken folds. Deborah was surprised to see Anna dressed in such an elegant skirt to go riding, but the young woman always had rather eccentric notions. Her hands – very white hands – hung over the edge of the armrests. Her perfectly oval fingernails were painted pale pink. When Theodore first introduced Anna to her, that was what she had been struck by: the delicacy and whiteness of the young woman's hands, and also her uncommonly long neck. For Anna had a very long and slender neck and this slight abnormality gave remarkable gracefulness to the way she held her head. Deborah herself was now all bowed, and for decades already her hands had been roughened, darkened and calloused by work.

'She's asleep,' thought Deborah, gazing at those hands in total repose. She had not noticed the pools of blood all over

the terracotta tiles. She carefully removed the cake from her basket to leave it in Sleeping Beauty's lap, as a gift for when she wakened. But as she placed the still-warm and fragrant cake on the cashmere cloth, she saw what had become of Anna – or rather, what was partly missing of Anna. Deborah did not cry out; she was dumbfounded by the sight of the headless young woman, sitting peacefully in her armchair by the fire. It took her a few moments to recover her wits. She reached out a trembling hand towards the absent face, but immediately drew her arm back to her chest. She looked round, and saw at last the bloodstains on Anna's shoulders, on the back of the chair, on the floor. 'So that's what it was,' she murmured, bending down to the ever-keening dog, 'in your own way, poor creature, you're singing the Kaddish . . . ' She pitied the orphaned animal, but not Anna. The dead did not inspire pity, only fear, amazement, meditation and grief.

For a moment Deborah stood before Anna lost in thought. To tell the truth, her mind was a blank. She had suffered many bereavements in her extremely long life, but had never, or almost never, seen a corpse. In fact death had always pro- ceeded around her with cruel and wilful irony, contriving, every time it occurred, to steal the body, the deceased's entire body as well its spirit. So most of her loved ones had departed this world without funeral or burial – passed away, body and soul. Her mother and younger brother, her two daughters and one of her sons-in-law were all gone without trace once death had claimed them. And this scourge was effective even in retrospect, since the little cemetery where her ancestors lay in a faraway village in Galicia had been desecrated, destroyed during the last war. Deborah was doomed to a life of recur- ring grief of utter starkness.

This time thieving death had only half done the job: all it had stolen was the head. Finally recovering from her chilling paralysis, Deborah went in search of a sheet, and having found one, of plain white, she returned to the drawing room and

draped it over the body and the armchair. The dead woman seemed less frightening like that, more decent, although the draped chair looked a bit like a misshapen ghost. Then Deborah covered the two mirrors hanging on the walls, lit the candles in a copper candelabrum adorning the mantelpiece, and crouched right down on the floor, like the dog, to intone her lament. Onyx accompanied the old woman's droning with her incessant whine, and the rain soon joined their chorus in a second basso continuo.

The car arrived in front of Theodore Lebon's house. The child was still asleep. 'This is the place,' said the passenger. Carefully lifting Tobias so as not to wake him, he handed him to the driver. 'Stay in the car with the child, I shan't be long, I'm just going to see if anyone's about.' He got out of the car, gently closed the door and entered the yard. He went and knocked at the drawing room window. Onyx abruptly fell silent, raising her head with pricked ears. Deborah did not hear the light tapping on the pane; it was the dog's sudden silence that caught her attention. She too fell silent, turned to face the direction in which the animal had fixed its gaze, and got to her feet. She went to the window, drew back the cretonne curtains, patterned with small flowers, and leant towards the glass. The rain had stopped without her noticing; the yard was glistening with huge puddles and the foliage had a silver-grey sheen.

A young man – or was it a young woman, she could not see clearly through the raindrops on the windowpane – was standing in the yard. He inclined his head slightly by way of a greeting, so did she. She let the curtain drop back, tiptoed across the drawing room so as not to disturb the dead woman's silence, and went out through the kitchen door. The dog followed her. She walked round the house and stepped into the yard. The sky was reflected on the wet ground, the colours of the flowers had gained brightness. The visitor came towards

her with an air of kindness and held out his hand. His hand-shake was firm and full of warmth, of gentleness, and it left a quiver of sunshine and water on her skin that subtly perme-ated her whole body. Like a smile imbuing her flesh. Deborah closed her eyes, a fleeting image had just flashed before them; an image rising from the depths of her great age, that of a fluffy white goat-kid lying on the surface of the sea. A kid drifting on a meadow of spume whose luminous flanks shed light, like the brightness of dawn, or of moonlight, on the surrounding waves.

The visitor touched her shoulder to bring her back to the present, then he explained why he was there. He told her that he had found the little boy on the road, and had brought him back here, but as he sensed that some tragedy must have occurred in this house, he suggested that the old woman take the child with her, away from this place.

Deborah nodded, she did not ask any questions. Tragedy had indeed struck, it seemed pointless to go into any further detail. All she said was, 'It's true, his mother's just died, but she's alone in the house, it's not right to leave a dead person alone, with nobody pray, nobody keep watch.' After more than seventy years in the country, Deborah still had a strong accent, and continued to make grammatical errors.

The young man understood her, but nevertheless per-suaded her to go home with the little boy while he waited there, in the yard, for the father to come back. 'So after all there will be someone to keep watch,' he said, 'albeit from outside.'

Deborah scanned his face, decided he was trustworthy and murmured, 'Blessed be the Judge of Truth.' Then she went and locked the kitchen door, hid the key in the rusty watering-can and returned to the yard.

The young man accompanied her to the car, woke Tobias and placed him in Deborah's care. He got the tricycle out of the boot and gave it to the child, who immediately jumped on

and pedalled off down the road with the old woman, the reasons for his escapade already forgotten.

The driver began to grow restless. 'Can I drop you off anywhere?' he grudgingly offered.

'No, thanks, I'm going to stay here for a while. Don't worry about me. Drive carefully,' he replied.

The driver did not press him. He turned on his radio and drove off. After all, this was none of his business and he had wasted more than enough time already.

The young man went over to the drawing room window, and stood there gazing at the clouds, at the peacock nestling by the wall, and the hollyhocks. The dog had settled at his feet, with her head raised, waiting to be patted. Far from rousing her mistrust and hostility, the presence of this stranger calmed her. Anna sat on the other side of the wall like a ghost enthroned. Beneath her white shroud, a smell of sugar and cinnamon mingled with that of dried blood.

It was not until evening that Theodore came home, covered with mud, his clothes torn. He had the staring eyes of a blind man. The police were with him. After hours of fruitless searching, he had decided to alert the police; he needed help to continue and extend his search, he wanted every inch of marshland turned over, every thicket scoured, all the canals, ditches, ponds and rivers dragged.

The young man came up to him, but Theodore did not see him, did not hear what he was saying. He was not all there any more; he had vacated his body, was no longer of this earth or time. He was exiled in Anna's death. He was drifting off into a hell of absence, of waiting, and loneliness. The abduction of Anna's head was matched by another abduction: that of his reason. So the young man gave the police some information about the child and Deborah's visit to the house, then when he was given permission to leave, he slowly walked away and disappeared into the dusk. The dog followed him for a while,

but was bound to return to her masters' house, and as soon as she got back, started whining again.

An autopsy was conducted on Anna's mutilated body and an investigation opened into the circumstances of her death. The verdict was that it had been an accident, and the place where it occurred was identified. Not far from the Lebons' house was an avenue leading to a manor house that had long ago fallen into neglect. The roof had collapsed, tufts of weeds spilled out of the gutters, and there were even a few shrubs growing among the rafters, covering the building with quivering fresh-green roofing. This avenue, on which Anna liked to ride her mare at a gallop, was shaded by big trees with leafy branches that no one lopped any more. The owners of this house had once taken great care of their property, even transformed the avenue into a pergola, installing supporting arches at regular intervals on which the springtime wisteria wove its luscious mauve festoons with their sweet and heady fragrance. But those days were long past. Apart from Deborah, no one could remember having seen the wisteria in blossom, though according to some romantics the scent lingered on for years after the flowers disappeared. At one time the place had been known as Lovers Lane, for this sweet-smelling canopy of shady foliage that rang with the trills and twitterings of birds was an invitation to amorous dallying.

The afternoon that Anna took off at a gallop, seated bolt upright on her mount, the old pergola was redolent no longer with the scent of wisteria but with just as strong a smell of leaf-mould and mildewed bark, of moss and ferns. It was as humid as a hothouse underneath it.

Long rays of straw-yellow and golden sunlight filtered through the tangled branches. These shafts of light fell obliquely, making the pergola's green and bluish shade tremble where they passed. And it was this blend of various spells

that elated Anna – the speed, the smell of her horse in a sweat mingled with that of the soil and plants, the shifting light and shade, the piercing birdcalls, and those little bubbles of sun-light occasionally spinning in the air, clinging to her eyelashes, delightfully blinding her.

And so it was, in a state of sensuous exhilaration and at a fast gallop, that Anna hastened to her death. Her eyelashes dotted with tiny grains of sunlight, she did not see the wire stretched across the avenue. A wire that had been attached to the sup-ports of one of the arches on the occasion of a party given in the past, for the purpose of hanging up paper lanterns. But the supports had sunk a little in the rain-softened earth, and the thin wire intended for hanging coloured lanterns from was suddenly transformed into a treacherous blade. It was at just the height of the horsewoman's neck, and sliced straight through it. Her head flew off and rolled on the ground. The body, contracted in a sudden seizure, remained stuck in the saddle and propelled by her own impetus the mare continued on her way. Then, as she was not receiving any further instructions, Obsidian calmly took the route home, as her mistress was in the habit of doing after this part of the ride. The head lay in the middle of the avenue, tipped over on one cheek, wide-eyed in astonishment. The sun no longer pearled its eyelashes, which were now glazed with only a few splashes of mud.

But now this head had disappeared, and no matter how meticulously the searches were conducted along the avenue and in the vicinity, they did not lead to its discovery. While there was no doubting the verdict of accidental death, the disappearance of the head gave rise to many questions and theories and fuelled many absurd rumours. It was suggested that some scrounging stray dog might have carried the blood-ied head off into some corner to devour and gnaw, or that some large bird of prey had seized on it to feast its young,

which was plausible. As for more fanciful theories, involving some malevolent creature lurking in the fens, these excited none but superstitious minds with a craving for the sensational. And in the end this baffling affair was classified as unresolved.

Theodore would not accept any hypothesis, and refused to come to terms with this disappearance. He declared the vault in which his wife's mutilated body was laid to be a temporary resting-place only, and no memorial stone was laid on her grave. So this was no more than a simple mound with a wooden cross placed on it, a grave of monastic austerity.

Theodore wanted Anna's body to be laid in the ground whole – as it had come into the world, and inhabited this world for thirty-six years, seven months and eleven days. Whole and inviolate in her beauty, as Theodore had come upon her in a street in Nantes some ten years before, haloed with light in the midst of the fog – the very embodiment of love. Whole and respected, as it had been created, in the image of God, and containing the breath of the Holy Spirit, as it was to rise again on the day of Resurrection.

Theodore had never been able to resign himself to the scourge that had afflicted his family for generations, the affliction that his grandmother Deborah, the primary victim, met with contemplative silence, full of secret and determined undauntedness and fervent pride. But he did not have Deborah's endurance, her pure and unyielding faith, and he who had until then been a man of gentleness and patience, a kindly recluse, began to grow twisted and burn from within. He had always shown love for the living and respect for the dead, when suddenly his most dearly beloved among the living was snatched away from him and she was ignominiously outraged in death. This death, on top of all the others, and made worse by additional theft, caused an eruption then of all the anguish of unfulfilled mourning that had lain dormant deep inside him since his childhood and youth. And he became a man of

31

grief, a lover stricken with fatal loneliness, a believer banished from life, from love, cast out from light.

It was during the night following the burial of Anna's amputated corpse that Theodore suffered a stroke. As he was at home on his own – Tobias had remained at Deborah's house since the day his mother died – he was not found until late the following day.

When he returned after a long stay in hospital, then in a convalescent home, he was no more than a semi-sentient being; half his body was paralysed, and his hair, which was only just starting to grey before the accident, had turned completely white, the ghostly white of his blanched skin, gaze, and heart.

Deborah moved in to look after both father and son, widower and orphan. Once again it fell to her to keep watch.

DEBORAH

Though you test my heart, searching it in the
night, though you try me with fire, you shall find
no malice in me. My mouth has not transgressed
after the manner of man; according to the words
of your lips I have kept the ways of the law.

The Book of Tobit 17: 3–4

Deborah came from far, far away, and long, long ago. She was born before the turn of the century in a village in Polish Galicia, and until the age of nineteen she lived in her *shtetl* on the banks of a river called the Lubaczowka. But poverty was rife there, and persecutions ritually conducted against the people of her community. And that is why one day, after her father died, she left her village with her young brother and her mother. All three, loaded with bags and cases, set off on a long journey. Taking a series of trains, they arrived in Hamburg where they camped in makeshift lodgings, among hordes of poor wretches like themselves who came flocking from all around in the hope of finding a new and better life across the ocean.

Already exhausted, Deborah and her family waited more than a month in Hamburg before they were able to board a steam ship sailing for America.

Her mother kept, folded in an envelope slipped under her bodice, a letter that a cousin, who had left three years earlier, had sent her on hearing news of her father's death, in which he invited her to come to New York where he himself had settled with his family. He wrote that everything was possible over there as long as you were prepared to wrestle, as Jacob had wrestled with the angel, for a freedom that was offered as a challenge, test and opportunity.

But her mother did not want to leave, for leaving meant abandoning her dead, all the members of her family buried in the little cemetery tucked away behind the village in the shade of a birchwood forest. Who would take care of them? Who would guard their peace, which was constantly threatened by men of violence prey to recurrent bouts of hatred, who, not content with oppressing the living, sometimes

sought amusement too in molesting the dead by desecrating their sacred resting-place? Who would come and recite the Kaddish and intone the devotions before their tombstone on the anniversary of their death? Who would leave prayers and blessings piously inscribed on pieces of paper at the foot of the stele so as to maintain a dialogue with the departed? Her mother was devout, fearful and superstitious. Yet in the end, with a heavy heart, she gave way.

Through cunning and persistence, her younger brother Mordechai, then aged fifteen, managed to get round his mother. He mainly threatened to run away and try his luck alone, leaving her behind on the banks of the Lubaczowka to commune with the dead. He wanted another life, a real life, and he dreamed only of the New World that gave rise to such fabulous reports, while this poor patch of ground that was the Old World produced nothing but sobs mingled with bitter sweat. So forced to choose between the living and the dead, her mother resigned herself to emigrating so as not to be separated from her son.

Deborah scarcely took part in their discussions; she was calm and deliberative, she always considered both sides of the argument. She loved her village, its river and the murmur of the wind in the birch trees, she honoured the dead and respected the living, the wicked and the just equally. Her respect extended to the animal world, and even the vegetable world. Her faith in God was at once simple, absolute and rigorous; she regarded the entire world of living beings and inanimate things as created by God and felt that it was only right to look with favour on every particle of this immense and mysterious Creation. On life, and time. She often repeated the words that God addresses to Cain when he appears embittered and angry because his offering does not meet with approval: 'Why are you so resentful and crestfallen? If you do well, you can hold up your head; but if not, sin is a demon lurking at the door: his urge is toward you, yet you can be his master.'

So she kept her head held high, silently bade farewell to her homeland, and as her sole souvenir picked up a pebble from the banks of the Lubaczowka and wrapped it in a handkerchief that she knotted and stuffed in her pocket. Just a grey pebble with fine pink and white veining to contain all her homesickness.

The day of sailing finally arrived. The Rosenkranz family found themselves cooped up in third class quarters, which reeked of squalor, garlic, sweat and vomit. Mordechai's radiant dream soon turned into a nightmare when seasickness confined the young adventurer to a mattress of damp straw in a narrow metal bunk. For all that she fingered the amulets round her neck, with the names of protecting angels scratched on them; his mother too was laid low with terrible nausea. Only Deborah did not succumb. But debilitating though this sickness was, it proved quite harmless compared with the subsequent scourge. Typhoid broke out on board and within a few days the epidemic had transformed the huge floating slum into death's waiting room. Mordechai too was seized with a violent fever, became covered with purple blotches and delirious. His mother found the strength to defy her own seasickness, and held her son in her arms, laid across her lap, in order to rescue him from the stench of rotten straw. She sang lullabies and psalms to him, wiping his face and neck with a scarf so drenched it no longer absorbed anything. Mordechai's delirium passed, and he started whimpering, ever more feebly, like a tiny puppy. Then he fell silent, his mouth wide open and his eyes rolled back.

Deborah cried out and, falling to her knees at her mother's feet, while her mother continued to rock and caress the stiffened body, she wept.

Her mother shoved her aside, saying, 'Now, stop it, he's asleep! You're going to wake him up!'

'But he'll never wake again, never again,' Deborah sobbed.

'Of course he will, he's just had a bad dream. He's going to wake soon, once we get home. Because we are on our way home. All this has been nothing but a bad dream. But it's over now, and we're going to have a big homecoming party when we get there, when we wake up . . .'

Deborah tried to reason with her, to no avail.

'You're so stupid!' her mother cried. 'Can't you see that a dybbuk's taken possession of your brother? A person's always more vulnerable when travelling, and evil spirits take advantage. But I'm looking after him, I know the prayers for exorcism, and I'm going to drive out the dybbuk. I'm stronger than any demon or evil spirit, I can take care of my son!'

Some of the crew, detailed to rid the ship as quickly as possible of typhoid victims, came to get the body. Still seated, as on a throne, like some ragged and dishevelled *pietà*, the mother clasped her son to her bosom, denouncing and cursing them.

'Avaunt, evil spirits! I know who you are, servants of the devil, I'll never let you near my son!' And she spat in their faces.

These men were brutes, and they behaved as such. They had no time to waste in discussion, especially as they could not understand a word of most of the languages spoken on that diasaster-stricken ship. They did not try and argue with this *pietà* transformed into a Fury; they slapped her face, so violently that she rolled to the ground, tore the body from her clutches and carried it off. In a complete daze, the mother got on her hands and knees and rummaged in the straw of her pesthole. She thought she had just given birth to her little Mordechai and that the demon Lilith, known as a danger to the newborn, had stolen him from her. Then she rose to her feet, and yelling for Lilith to return her baby, she ran here, there and everywhere, barging into the people who were crammed in this huge and heavily pitching sump of squalor. Deborah ran after her, but her mother neither saw nor heard

her. The young girl began to think she was indeed imprisoned in a bad dream – a frightful dream, where the tragic vied with the grotesque. Her mother, so God-fearing, always so strict in her observance of modesty and decency, was screaming like a woman possessed, bare-headed and unkempt, her clothes in disarray and stained with filth.

After a long struggle with the invisible Lilith, her mother came to her senses – or rather, a foreboding penetrated her madness. She rushed for the stairs, with Deborah still on her heels, reaching the upper deck just as Mordechai's body was being thrown into the sea.

'No!' she cried. 'You shall not give the light of my soul to Leviathan to feed on!' And clambering over the side, she threw herself into the waves to rescue her son from the huge sea monster, having already defied the dybbuk, then the treacherous Lilith. And the waves immediately swallowed her up.

Then, as she stood there on the deck facing the swelling seas, Deborah instinctively performed the gestures her people had always carried out in mourning: she tore her jacket, from the left shoulder to the waist, and pronounced the blessing: 'Blessed be the Judge of Truth!'

When she returned to her place on the third class deck, she discovered that all their belongings had been stolen. But her bewilderment and grief were so great that this theft had no effect on her at the time. She felt bereft enough already, of her brother and her mother, claimed in rapid succession by the ocean. And bereft also of the homeland she had left, a loss she only now began to measure.

She shed so many tears that when the ship arrived in the port of New York, her eyes were all swollen and redder than a white rabbit's. Through painful eyelids she glimpsed the tall silhouette of the Statue of Liberty, a sight that made other passengers weep and sing with joy, the children dancing

round their mothers' heavy skirts like spinning tops, but one that broke her heart. The torch of Liberty was held aloft like a giant dagger in the lavender-blue sky, and the statue's raised arm came between sea and sky, ship and city, thwarting hope. Deborah could think only of Mordechai and her mother, gone to their watery grave, and surely eaten already by fishes and sharks.

Had they left the land of their forefathers, then, only to undergo these tribulations and this disaster, only to suffer a death as cruel as it was unholy, without ritual or burial? Even worse, for theirs was a shameful burial, as her brother and mother had been cast into the ocean depths like sins, like the crumbs people emptied from their pockets on the afternoon of the first day of Rosh Hashanah and threw in the river, while reciting verses from the Books of the Prophets, so as to unburden themselves of any wrongdoings they had committed during the year. Every autumn, together with her family and the people of her community, Deborah had gone to the banks of the Lubaczowka and, while imploring divine forgiveness, had thrown in her handful of sins in the form of crumbs and little pebbles.

Her torn jacket flapped gently on her breast, and her heart was chilled, pierced with spray, with the cries of seagulls, and with frozen tears. The sun caught the skyscrapers of Manhattan in the distance; their glass facades gleamed like vast sheets of quartz. Surely that was no city on the horizon, but a steep mountain with smooth glistening rock-faces. Could it be the mountain of which Isaiah had spoken: 'On this mountain the Lord of hosts will provide for all peoples a feast of rich food and choice wines, juicy, rich food and pure, choice wines. On this mountain will he destroy the veil that veils all peoples, the web that is woven over all nations.'

But her vision blurred, the glass mountain danced before her stinging eyes. Mordechai, who had so fervently desired to sit at this banquet, had been for ever turned away. For her

brother, her mother and herself was reserved only a banquet of tears and sorrow. Then, so as not to allow the most terrible of sins to pounce on her – the sin of despair, which tried to possess her soul like the fever that had stricken her brother and the madness with which her mother had been afflicted – so as to remain favourably disposed towards this world that was crushing her, towards her God who was testing her beyond measure, she turned to the east, somewhat unsteady on her feet, and murmured the following verses of Isaiah's hymn: 'He will destroy death forever. The Lord God will wipe away the tears from all faces; the reproach of his people he will remove from the whole earth.'

She mumbled these words with her fists held clenched to her lips to contain the tears gathered in her mouth, and which she had to swallow since she could not shed them. No, she could not weep any more, she must not, for it would mean life flowing out of her, so exhausted was she, it would mean the waters of the Flood drowning her, so despoiled by misfortune were her heart and mind, exiled to the boundaries of time – expanded, blasted boundaries – to the core of the great myths related in the Book, the only book she had ever read. Lost in the rejoicing crowd, Deborah felt herself transplanted to the age of Noah, and of Job.

The ship had deposited its human herd at the foot of the beautiful mountain whose sides glinted like mirrors, but this herd had no right to scatter among the glass cliffs. They were rounded up, sorted and categorized, and re-embarked on a ferry that took them to a small island called Ellis Island, on which stood a large brick building, its windows and corners decorated with cut stone, and flanked by four towers, each crowned with a copper dome. A lot of people thought it was a palace; a palace of marvels, but which for some would turn out to be a prison.

This island should have been named Babel – every

language was to be heard here. Robbed of her baggage and with no one to accompany her, Deborah followed the other immigrants who streamed along corridors and metal stair-cases, not really knowing where all this walking was taking them, or when it would stop.

Doctors were on guard and inspected every new arrival. They seemed weary and suspicious, and behaved strangely: they searched people's faces inquisitorially, examined their neck, ears and mouth, and especially their eyes, lifting their eyelids with a button hook to make sure the newcomer did not have trachoma. When it was Deborah's turn to appear before one of these doctors, she excited immediate suspicion and was examined very thoroughly. And sentence was passed: she could not enter America, her eye disease, ruled a threat to public health, condemned her to returning whence she came.

She was not allowed into the Registration Room where admission procedures were completed. She was turned away, along with other undesirables, the old, the sick and the handi-capped. There was no one to defend her, to help or support her. She was just a reject nobody cared about. Yet she knew very well that her eyes were healthy, it was only because grief and exhaustion had inflamed them that they were so red and swollen. But she did not try to plead her case, to explain. What was the point? She did not even know the address of the cousin who had settled in New York, and anyway he might have changed his name on arrival in this new country, as some people did in order to integrate more quickly and discreetly. Nothing remained of the cousin's letter but what lay at the bottom of the Atlantic, along with the amulets inscribed with the names of angels. The letter had brought disaster, it was right that it should be left to disintegrate in the depths of the ocean. As for those guardian angels' names of splendour, they must be swimming among the fishes, shots of light darting through the watery shadows, secretly caressing the foreheads of the drowned.

She had nothing, neither family nor home, nothing to call her own, no money, and now not even a homeland. She was barely twenty, and bore the weight of a past going back several thousand years. She was a descendant of Abraham and Moses, a distant grain of sand from the desert of Judea, carried by the winds of exodus to Galicia, and now stranded on a tiny island in the ocean before cliffs as dazzling as they were inaccessible. All she possessed was the dress she had on, her torn jacket and a big woollen shawl. She also had in her pocket a grey pebble veined with pink and white. And what passed for her eyes were two graves in which lay the bodies of her mother and young brother reduced to tears.

Seated on a bench in the room for the excluded, she remained very straight-backed, with her head held high, and her heart empty, corroded with salt. She expected nothing more – truly nothing, neither death nor life, still less a miracle. The emptiness within her was so close-packed, so dense, that not even evil could slip inside to sow confusion and lay its snares. So pure was the emptiness within her that only the ineffable name of God could ring there in silence.

After a forced stay under strict surveillance in a barracks on Ellis Island, she was made to board another ship sailing for Europe. She watched the skyscraper, a pink-opal colour in the early morning light, recede into the distance, and the Statue of Liberty diminish in size and finally disappear. This statue, which on their arrival some of the women had greeted on their knees, crossing themselves and exclaiming, 'Madonna! Madonna!', was no more to Deborah than an implacable sentinel brandishing a torch without light or warmth, ready to come down with the heaviness of a club on this flotsam and jetsam that were the old, the sick and the disabled, whom the New World did not want on its territory for fear of contamination, of degeneration. It was just an enormous Golem, not of clay but of bronze, made by men anxious to forget the

wretchedness of their origins, and even to deny the existence of this wretchedness. The female Golem of Health, Vitality and Success did not allow entry to the orphan girl with funereal eyes, kin to Noah and Job, and sent her back to sea.

Deborah remained for a long time at the ship's stern, wrapped in her old shawl. She contemplated the vessel's broad wake, ever the same – a milky turbulence in which the sea inscribed its lack of history, and time recounted over and over again its blank tale of forgetting and recommencement.

And her eyes gradually got better. Cleansed by the sea wind, her gaze became more polished than the pebble slipped inside her pocket.

During the ninth night of this voyage of exile in reverse, she dreamed, which was something that had not happened to her for months. The little goat named Mejdele, her favourite of all the goats that had succeeded each other in the yard of their house in Galicia, appeared to her. The goat kid trotted on the ocean, stopping here and there to sniff the air or browse on a patch of spume. The swell did not upset its balance nor wet its very fluffy white coat. It gambolled along, without straying from the invisible path it had marked out for itself in this vast aquatic pasture. Then it settled down on the water, with its legs tucked under, neck outstretched and head held high, and ears pricked.

Mejdele had stopped moving about in order to be more attentive. The little goat's eyes glistened like the candle of remembrance lit in honour of the departed; the ocean all around reflected their translucid golden glow. And a low, sonorous singing rose from the depths of the water. The kid's eyes kept growing bigger and bigger, blazing ever more yellow, their radiance shedding a softness of dawn. The singing reverberated beneath the ocean surface; it was the voice of Deborah's father, the Cantor Yoshe Rosenkranz, making the waters throb with his wonderful plaintive melodies. A tenor

voice blending with the sound of the waves, with the roar of the wind, a voice developing ever greater amplitude. It was the voice of her father and of her childhood, the voice of sabbaths and festivals, the very breath of man in his living glory, in his mortal vulnerability, in the madness of his faith and hope, in the goodness of his love. It was the secret heart of the world beating in the night, in Mejdele's flanks, in Deborah's blood.

She woke, or rather she rose in her dream. She went up on deck and crept to the stern. The water showed white in the darkness. The little goat was sea-foam, its eyes a heavenly constellation, her father's voice lulled the night, lulled the unburied dead. Yoshe Rosenkranz's singing hovered over the ocean, wheeling like a bird. Deborah felt this was the place where her brother and her mother were submerged. She had no candle or light. She tore off the half-rent flap of her jacket, tossed it overboard with the pronouncement of a blessing. The small piece of cloth seemed to blaze with light for a moment. Slowly Mejdele's silhouette faded, the singing died away, but a brightness like a smile spread upon the waters.

The next day a young man, as ragged as she herself had become, spoke to her. He had the temerity of the shy, and the disconcerting wisdom of the innocent. He was Polish; Deborah spoke his language as well as Yiddish. He had moon-like eyes, completely round and very pale blue, almost transparent, which, despite the weariness and distress that marked his features, gave him a look of radiant candour. Indeed, it was because of that moon-like expression, and also because of his fingernails chewed to the quick, that he had been turned away from the New World. It was thought that he looked like an idiot and he was suspected of some mental deficiency. He was no more able than Deborah to defend himself, to prove that he was of sound mind; he was merely anxious and extremely emotional.

So it was with considerable stammering that he told Deborah he had noticed her the previous night when she crept to the stern and leaned out over the sea. He thought at first that she wanted to drown herself – he had already fought against the same temptation on more than one occasion since his detention and then expulsion from Ellis Island – and he approached her without a sound so as to restrain her at the last moment. But then he heard the sea singing, and saw a smile trembling on the water. And for 'that' – he did not know what to call this quiet wonder – he wanted to thank her. Just to thank her.

Deborah listened to him in silence, her hands clutching her shawl, which she held crossed tightly over her breast to hide her torn jacket. And he just stood there in front of her, staring at her with those round ingenuous eyes. The young girl's silence did not bother him, it did not even occur to him that she might not understand his language. This absurd and word-less confrontation went on for hours; hours spent staring at each other, not under any amorous spell, but because they had both reached the same degree of exhaustion, of extreme lone-liness and denudement. They stared at each other without curiosity or calculation, without expectation, and their gaze travelled through the face and body of the other as through a window. A window looking onto absence, the light of absence. They stood before each other as so often in recent months they had stood before sky and ocean.

Nothing else happened that day, nothing but that slowly palliative process of gazing, in which the suffering of each was eased, imperceptibly transformed into comfort. They met again in the days that followed. They would stand side by side, leaning over the rail, contemplating the sea and suspended time, still without speaking. He sometimes laid his hand on Deborah's; not that he caressed her hand, or squeezed it, he merely assured himself of its presence. Sometimes too he would release a long sigh that had the lightness of some

approaching consolation, or give a faint smile directed at empty space, at no one at all.

The day before their arrival the young man broke their silence.

'And tomorrow? What will happen tomorrow?'

'Nothing,' Deborah replied. 'From now on, nothing.' And she thought, 'We've lost everything at sea, we're castaways. That's what we'll be on land too, that's what we'll always be.'

However, he went on: 'I can't even go back to Poland, I've nothing left there, the little that I had I sold in order to get away.'

'I have nothing left there either, and no family,' Deborah replied, echoing what he had said.

He reflected, then declared, 'So, let's go somewhere else!' As if they were deciding on a country, and it was obvious they would go there together.

And so they did, moving from one place to another, always at each other's side. At first they stayed in Germany, he hiring himself out as a docker, she working as a seamstress. Their first-born daughter, Rosa, was born in Bremen. Then they came to France, tried to survive in Paris. But life was too hard in the city and they were homesick for fields, forests, rivers. So one day, having heard talk of a region where seasonal workers were hired, they took to the road. And that was how they ended up in the heart of the Poitevin Marais region, where, beneath the vegetal earth lies another earth of bluish grey, saturated with water and oceanic memory. It was in order to extract this deeply buried clay, to wrest it from its millenary slumber to feed the brick-kilns in the vicinity, that the moon-eyed young man had come there. The work was arduous, and poverty clung as tenaciously to their lives as the mud to the soles of their shoes. But they did not complain; despite everything, they felt at home in this elsewhere to which the vagaries of fate had finally led them. Deborah gave birth to a second daughter, Wioletta.

At first they were treated as outsiders, with suspicion, especially Deborah, who never took communion or made the sign of the cross when she attended mass. That set tongues wagging, and besides they both spoke the language of their host country so badly. But little by little they inserted themselves in the landscape, the locals got used to them, to their foreign lingo and their accent, to their sometimes baffling ways. People grew very fond of their little girls with the names of flowers, and the younger one was born in the village. They were quiet folk, hard-working and obliging, and they had an honest look in their eye. So they were accepted as equals at the long table of shared poverty.

Deborah did not convert. Though she went to church on Sundays, it was to be near her husband in what she called 'his house of prayer'. She knew he was happy that she should be there, silent and devout, as he had seen her for the first time, as she stood looking out to sea at the stern of the ship, her face to the wind, the spray, and the mystery of fate. She would take her place at the back of the church, in one of the rear pews, and her gaze would travel through the nave, not settling on anything, or anyone, neither on the statues, the ex votos, the various candles, nor on the faithful, not even the priest. Her gaze ascended the rays of light filtering through the glass windows, glided through space like a bird flying over the sea, never failing or lingering. A migratory gaze hastening to the dwelling-place of that God whose name was not to be uttered, to a far-flung elsewhere. And the murmur of her people's chanting, of the voices of her youth and childhood, ancestral magnificent voices, resounded secretly within her body; a combined murmur of ocean, night and tears that drifted in her heart. The daughter of Cantor Yoshe Rosenkranz bore faithful witness to her heritage, and righteously honoured his memory, even on a church pew.

She gave voice to this murmur one evening a week, at night-fall on Fridays, when in the close intimacy of her home she would light the two candles as she recited the ritual blessing, then stretching her hands over the head of each of her daughters, she would say: 'May God liken you to Sarah, Rebecca, Rachel and Leah.' She had to assume the role normally assigned to the father of the family. In fact it fell to her, by herself, to fulfill every role – that of an invisible community, of a conduit of memory – and to build in the night, amid the marshland mists, an immanent synagogue. She would sing the song of welcome to the angels of the sabbath in that frail voice, but one that then took on warmer and more supple inflections. Whenever their mother sang the *Shalom aleikhem* her daughters would say to each other, 'Mother's put on her candle voice,' and her husband would think, 'She sings like a saint.'

He took part in this ceremony as a silent witness, a little mystified but very moved. He watched his wife whose hand fluttered from the candle flames to her face, which she would cover now and again, from the light to the loaf of bread on the table, which on this special occasion was covered with a cloth, and from the bread to her daughters. And on these evenings he sensed something quivering in the light in which Deborah's hands moved, in the glimmer and solemnity of her singing; something resembling that smile glimpsed upon the waves, on the high seas, one night already long ago. And in his simplicity, he called the sabbath 'the evening of the wondrous smile'. He then experienced a joy of as much peace and plenitude as during the celebration of the eucharist.

And he dug, he dug the earth, a seeker of clay as others were of gold over there in America where he was not wanted. But he loved this blue and loamy earth which by the alchemy of fire would later become hard and red. He enjoyed being in the

marshlands where between the four elements a marriage of such subtle and deep harmony prevailed.

But one day he was sent to dig the earth in a completely different place, where the elements were hostile to men, and men were enemies with each other, where there was neither Friday nor Sunday, where the week was featureless, time was levelled, and the days and nights indistinct from each other. The mud of the trenches was reddened only by the blood of men.

The day before his departure to the front he removed the chain he wore round his neck, with a metal medallion of the Virgin on it, and gave it to Deborah. 'So that she may protect you, and our daughters, while I'm away,' he said. Deborah dared not object that he was more likely to have the greater need of protection, and she knew from experience that talismans did not save people from misfortune or death – her mother had drowned wearing clusters of devotional amulets under her clothes. She took the medallion in silence; all she had to offer him in exchange were the simple words – such poor sweet words – of love and of awaiting his return.

The earth in which he was made to flounder, to crawl, was not a beautiful grey-blue clay, it was slimy and reeking of human flesh. This was towards the end of the war, but war claims soldiers until the very last moment. A few days before the armistice the moon-eyed young man was blown up by a shell and his corpse engulfed in the mud. Another dead person with no body to bury entered Deborah's life.

His name was engraved on the municipality's monument to the dead, between Roncel Emile and Ruchier Albert. His melodious-sounding name, Boleslaw Rozmaryn. He was twenty-nine.

Deborah did not weep on learning of Boleslaw's death. She had never shed another tear since her stay on Ellis Island, not

that the source had dried up within her, but the tears no longer managed to forge their way to her eyes. She tore her dress from her neck to her breast. Her hands served as cries, sobs and lamentations. Seated on the floor of her widow's bedroom, she recited the Kaddish in a voice devoid of expression.

War was as ungodly, as thieving as the ocean, it did not give back the bodies of those it claimed. So Deborah took the tin medallion that Boleslaw had given her, she polished it until the miniature Virgin gleamed, then wrapped it in a small piece of cloth by way of a shroud. Then she buried these proxy remains in a big terracotta pot, said the funeral prayers and placed this miniature cemetery in a corner of the garden, sheltered from the wind and rain. She thereby attempted to circumvent the dismal fate that had befallen Bolko – as she always called Boleslaw – for she recalled the words of the Torah according to which it is considered a curse for the corpse of a human being to be left 'for all the birds of the sky and all the beasts of the earth to feed on, without anyone scaring them off'.

This semblance of a grave also allowed the two little girls, then aged nine and four, to allay their grief by improvising rather fanciful ceremonies in the course of which they imitated the gestures of the priest and of their mother, while repeating, jumbled up and mispronounced, phrases in Latin, Yiddish, and Hebrew, words in French and Polish, in local dialect and of their own invention. Their pidgin language was outlandish, but for all that far less incomprehensible than death.

Deborah kept the promise she made to Bolko the day before he left; her love remained intact and uncompromising, like the ocean they had for so long contemplated shoulder to shoulder, during their odyssey between two worlds. She remained true to him, not out of duty but simply because she was above

all true to herself, to her very rarefied notion of time, of destiny, of God; a notion of which Bolko, in his simplicity, and despite all the differences that should have divided them, had an immediate and intuitive understanding. And she never ceased to wait for him, just as she had promised.

This waiting was without illusion, Deborah never anticipated any miraculous return of Bolko. Beyond hope and desire, without impatience or anxiety, she awaited her turn to appear before the God whose name was ineffable, who 'will destroy death forever'; her turn to pass over to the other side of this extremely chaotic, brutal and sacrilegious world. And in the meanwhile – an interval which was to last a very long time – she worked, fulfilled her tasks, profane and ritual, to the best of her ability, and remained constantly vigilant lest sin – that rapacious beast greedily lurking in the shadows of misfortune, ready to pounce on any unwary soul or one yielding to despair – should cross her threshold.

She continued to go to church every Sunday, in memory of Bolko, though without relaxing her attitude, as stiff as that of a statue, a figurehead rather, cutting through the high seas, allowing itself to be plunged down into the water, whipped and lashed by the waves, raised into the void, driven into the unknown. A figurehead in sole command of a deserted vessel resisting shipwreck. Her gaze followed her endless migration elsewhere, nowhere. Yet sometimes it would settle for a moment on an image, that of the lamb carved in bas-relief on the front of the altar. She would then think of Mejdele, the little goat of her childhood that had been transfigured into a caprine angel on the dark waters of the Atlantic. Lamb or kid, the same overwhelming power, created out of nothing, out of transparency, emanated from their total vulnerability, and from such delicate flanks as theirs an immense song could resound, from those eyes in perpetual alarm a wondrous smile could radiate. When the congregation chanted the *Agnus Dei*, Deborah with her mouth closed would invoke the name of

Mejdele, weaving around it in a slow and sorrowful litany the names of all her dead.

War never admits to being completely over, even between two outbursts it contrives to sow further discord, fear and misery. As early as 1920 refugees arrived from several countries, seeking somewhere that was both more remote from the century's upheavals and where it was possible to find work, however arduous. Just as Bolko and Deborah had done several years before.

The flat landscape of the marshes, where water and land had been wedded in ambiguous conjugality for thousands of years, lay outside the turmoil, and the tile-works and brick kilns that stood on its soil were in regular need of labourers. More Poles as well as Czechs turned up; there were also a few Italians and one day even a Chinaman. Most of them left sooner or later, some settled, started a family, put down new roots.

Deborah's daughters grew up. Childhood fancies gradually faded from their minds, new passions began to smoulder in their adolescent bodies. They no longer performed their quaint commemoration rites before their father's imaginary tomb at the bottom of the garden. Their recollection of him was fixed in their memory like his name on the column of the monument to the dead. They no longer mixed up languages in an eccentric pidgin; they had made a choice. Rosa had opted for Yiddish in addition to French; she dreamed of going back there, to Yiddishland, as she called it, with her mother, and of picking up again the broken thread of their origins, of re-establishing the Rosenkranz line. While Wioletta, who insisted on being called Violette, had chosen only one language, that of the country where she was born and where she lived.

But the vagaries of love are often full of irony. At seventeen, Rosa lost her heart to a local youth of pure Marais stock,

called Xandre Lebon. She forgot her dreams of Yiddishland and far from returning to the Rosenkranz fountainhead she became confluent with the marshland rivers. Moreover, she had to drop her name of Rozmaryn for that of Lebon when, three months pregnant, she married Xandre.

Then came Violette's turn. She, who never did anything in moderation, fell madly in love with a young Polish emigré and suddenly nothing delighted her more than to be called Wioletka.

Rumours stole even into the depths of the marshlands. They came from the East, like a wind that every day became more gloomy and fraught with violence. A bellowing wind of hatred and ugliness rising from Germany and blasting across Europe, blowing on countries, towns, villages, overthrowing frontiers and laying waste to lives as well as ears of grain in their thousands that were soon to become millions. Ears of grain considered worthless, worse still, harmful – chaff of which the earth had to be cleared. The wind whistled and searched, searched all over German soil to root out the nasty chaff and destroy it.

Now it was not just homesickness that affected the workers from Bohemia, from Poland, it was mixed feelings of anger, sorrow, rebellion, and urgency. Some of them decided to return to their homeland, whatever the dangers incurred and the price to be paid. Wioletta's fiancé Sambor was one of these. 'But I'm Polish too!' the fervent Wioletta Rozmaryn reminded herself. And one day she packed her few clothes, went and knelt in front of her father's little terracotta tomb, said her farewells to Deborah and her sister Rosa, who was already the mother of two children, Valentine and Theodore, and she set off with Sambor to throw the Nazis out of Poland.

Theodore, then aged ten, retained for ever, engraved within him, the image of his aunt walking off down the road at Sambor's side, one spring morning. The shadows on the

ground danced almost indiscernibly with those of the leaves. They went off hand in hand, in a dusting of shadow and rosy light, beneath the vault of trees transformed into an aviary. Wioletka turned round several times, waving with her handkerchief, an ever diminishing flag that disappeared round a hedge. Then Rosa wept.

'Is it far where they're going?' asked Theodore.

'Very,' was all she replied in a choked voice.

It was all the further since the borders had just been closed and the young couple were going to have to go a very long way round, to make many detours. The child ran along the empty road, shouting his aunt's name. He wanted her to come back, or else to take him with her and Sambor. He loved the young woman dearly, he could not understand or accept her going like this, suddenly, very far away, leaving him behind, forgetting him. She was much more than his aunt, she was a good fairy, generous in her laughter, stories and songs, a marshland will-o'-the-wisp. Only the birds echoed his calls with noisy exuberance. Nature's indifference to his grief amazed him, and all at once he found he had been expelled from the enchantment of childhood.

They waited for news. The waiting went on for weeks, months, years, and no word came. Only the war came, it even sent its lackeys in verdigris livery into that region. Deborah endured those days as she had always conducted herself in this world, with her head held high, her gaze travelling off into the invisible, her mouth sparing of words and her heart filled with suppressed, unshed tears in which there was a quiet murmuring of songs of praise and lamentation, of the haunting voices of the deceased. But she who had so long since ceased to wait in expectation of any gratification now kept vigil on tenterhooks of anxiety and impatience. She awaited a letter from Wioletka, or better still, her return. Every Friday, with her hands raised in the air, she pronounced under her breath the

Sabbath blessing on her absent daughter: 'May God liken you to Sarah, Rebecca, Rachel and Leah.'

She was unaware that for years already, like millions of other men, women and children, her little Wioletka bore no resemblance to anything, to anyone. She was unaware that her youngest daughter had been shot dead with a bullet in the back of her head, along with Sambor and some other partisans, shortly after their arrival in occupied Poland, and all that remained of her were some bones at the bottom of a mass grave dug in a forest near Kielce. Furthermore, she never learned exactly what had happened, or where or how death had claimed her daughter. She received no notification of death. All she knew was that her daughter had died; one day the truth of this, which had been a long harboured suspicion that she dared not admit to herself, suddenly and finally compelled recognition.

Not only did the curse of death without burial bear down on all her loved ones, but furthermore, this time death had stolen the date as well, and so too the commemorative *Yortsayt*, which could not be fixed to any particular day.

One morning Rosa came to her mother, her fist held close to her heart. She said, 'Open your hand,' and on Deborah's outstretched palm she laid a little pearly white bead.

'It's one of Wioletka's milk teeth,' she explained, 'the last one she lost. She gave it to me long ago as a good luck charm. I want you to bury it with the medallion.'

And Deborah buried the milk tooth in the terracotta jar in which the weeds were constantly growing. But Theodore continued to await his aunt's return; Wioletka, the fairy's little white handkerchief still floated before his eyes, like an omen, a promise.

The disappearance of her sister and Sambor, and the entire destruction of Yiddishland, had set Rosa adrift in increasing melancholy. It was no use now dreaming of a journey to the

homeland of her mother, of Cantor Yoshe Rosenkranz, because that homeland did not exist any more, the inhabitants of Yiddishland had almost all been wiped out by an epidemic of hatred, and the few survivors had fled. She could not forgive herself for not having left earlier, for not having accompanied her sister, for not having shared her death – shared the fate of all her own people.

Her husband, her children were no longer enough to keep her in the land of the living; she gradually lost her appetite, her sleep, any desire whatsoever. She remained slumped in a chair all day long. She did not know who she was any more, what she was – Jewish, Polish, French, a marshlander, Catholic. She felt only that she was orphaned, not only of her father but also of her sister, homeland, past, faith, and roots. Orphaned of God, who had perished in Yiddishland, and not just once but several million times, in all the camps and mass graves in Germany and elsewhere. Rosa's thoughts were like those towns destroyed by bombing of which she had seen photographs, reduced to weeds growing wild amid the rubble.

One night she left the house without making a sound, she wore no shoes, took no coat with her. She went away wearing just a simple dress. She left a lock of hair on the kitchen table, lying on a sheet of paper. On the sheet all she wrote was: 'To bury in the terracotta tomb.' Rosa was never seen again. She in turn chose the path of disappearance.

Deborah buried the lock of hair along with the medallion and the milk tooth. Her husband, her two daughters, all three vanished into mud, into darkness; nothing remained of them but the pathetic scraps committed to a pretend family tomb.

From that day forward she stopped going to mass. She sometimes went into the church when it was empty; she would go up to the altar and gaze at the image of the lamb. She would stare at it, dry-eyed, waiting for the moment when the lamb transformed into a goat, acquired the appearance, the translucid golden eyes, and the smile of Mejdele. Only that

smile succeeded in relieving the burden of tears gathered inside her, lying stagnant in her flesh and mingling with it, like the dark blue clay impregnated with water that lay dormant beneath the topsoil. Tears that came from the Lubaczowka, the Atlantic, all the canals of the marshlands. She needed the very gentle warmth of this smile to counterbalance the heaviness and bitterness of the tears imprisoned in her body. And on the way back home to a house now empty she would very quietly sing these lines of a song: '*Zu ken men aroifgeyn in himel arayin / Un fregn bay got zu's darf asoy sayn?*'

Can someone go up to heaven and ask God if this is the way things should be?

THE LIVING DEAD

So now, deal with me as you please, and command my life breath to be taken from me, that I may go from the face of the earth into dust. It is better for me to die than to live, because I have heard insulting calumnies, and I am overwhelmed with grief.

The Book of Tobit 3: 6

So old Deborah moved into Theodore's house and she it was who brought up Tobias. Theodore's sister, Valentine, could not lend any support to her brother or take charge of her nephew. Yet she lived not far from them. She lived with her husband Arthur Lambroste in a little house built on the site of an old brickworks. The tiled roof was a faded red tinged with pink, the walls a brilliant white; Arthur had covered the bricks with roughcast so that his house, standing on the ruins of the factory, should look less humble. It seemed particularly tiny amid the large buildings that extended on either side: the kiln, consisting of fourteen heating chambers through which the fire once used to move, advancing from hearth to hearth, with an enormous chimney towering at one end, suggestive of a blinded lighthouse; and the shed where the products were left to dry. These buildings were both long and low-lying, their roofs almost coming down to the ground; they contained a vast space now doomed to emptiness, the preserve of dust and insects. The shed was open to the four winds, with birds nesting in the beams and rodents frolicking among the rubble and tile crates. The worm-eaten drying racks on which just a few rusty tools and fragments of terracotta lay were garlanded with spiders' webs, grown furry with anthracite dust over the passage of time. The big Hoffmann kiln was closed. Where the fire had long raced, danced, roared, now only cold and gloominess reigned. The little white house stood huddled between these two buildings, the one open to the four winds, to rain, to animals, and the other enclosing thick darkness. Two buildings fraught with emptiness, stricken with dereliction, with silence intensified by whistlings and rustlings and whisperings.

Valentine and Arthur were the reflection of these deserted

buildings. He was like that firmly closed oven in which fire no longer burned, that had turned cold and dark instead; indeed no one but he ever entered this palace of extinguished fires. He would shut himself up in there for hours on end, with only the bats for company. Some people said that he retired to this lair to drink, to get as tight as a tick; it was true that although Arthur did not go to bars, he was nonetheless frequently seen drunk. And he was miserable and churlish in his cups.

Valentine was like the draughty shed. With every passing year she drifted, unobtrusively, towards absence. She had big clear eyes whose rounded shape and moon-like expression were reminiscent of those of her grandfather Bolko. She seemed permanently prey to deep astonishment, sometimes even panic. When anyone spoke to her, she began blinking rapidly and a timid smile trembled on her lips. She would reply incoherently to any questions put to her and punctuate her words with brief bursts of very pretty, crystalline laughter. She was one of those creatures who seem to be constantly apologizing for being only what they are, and seem even to have come into this world without understanding the rules of the game, forever uncertain of the role they are supposed to play.

When Anna first met Valentine and Arthur she was struck by this obscure affinity between the couple and each of these internally very dilapidated buildings – two human beings whose hearts were out of sync with each other, in total discord, one being taciturn, increasingly surly and unsociable, the other an eternal child growing with age ever more dreamy, delicate, even frightened. Two human beings above all who should never have got married, his character serving only to heighten her vulnerability, and hers, by its weakness and passivity, able only to excite her companion's annoyance.

But as much as Arthur inspired Anna with nothing but wariness and unease, she got on well Valentine. She was very

fond of her sister-in-law whom she felt was so ill-equipped, afflicted with boundless and above all defenceless gentleness. She loved her gaze full of candour and her pretty tinkling laughter. She often visited the old brickworks, entering the white roughcast house heedless of Arthur's sullen mood, though he would grunt by way of greeting and leave almost at once with black looks. She would sit next to Valentine in the only room on the ground floor that served as kitchen, dining room and living room. They would chat for a while, about this and that, and these were times of tranquil happiness. Sometimes Anna took Tobias with her, then Valentine would tell the child stories; she would forget her shyness and suddenly speak fluently, making up tales of rare poetry. Habitually scared and set stammering by a trifle, this woman turned out to be a wonderful storyteller, drawing on her daydreams for an abundance of images. She had the gift of making words visible, almost palpable. Tobias would listen to her openmouthed, while Anna allowed this voice to work its spell on her, a voice steeped in the winds, mists and light of the marshlands. The voice of a woman mostly reduced to silence, lost in the murmur of words whirling round inside her like swallows that have got into an attic and then are unable to find their way out through the skylight. And escape, when it finally came, brought a soaring delirium of space, song and light.

'Your sister is like a beautiful kaleidoscope,' Anna told Theodore one day, and he thought of Violette, the fairy of the marshlands who had enchanted his childhood, then disappeared into the upheaval of war. The two Rozmaryn sisters had left their mark on Valentine, but the younger one's imagination was overlaid with a deep melancholy inherited from the elder one. Drop by drop, with the slowness of poison, the melancholy that had consumed Rosa seeped into her daughter's flesh and mind. And Theodore suspected Arthur of doing everything he could to entrench Valentine in this malady. Little did he know how well founded his suspicion was.

It was not that Arthur had ceased to love the woman he had married in his youth, but this love had gradually become inverted. He now harboured a completely negative, acrimonious passion for Valentine, and he cursed everything about her that had once captivated him. He resented her for the light she carried in her heart, for her infinite patience, for her capacity for wonderment at the simplest things. For this light had not illuminated him, on the contrary it only succeeded in accentuating, hardening the darkness accumulated inside him, and her patience was a defiance of him; as for that childlike spirit she miraculously preserved as time passed, it rankled him, who could not look on anything except with a bitter, jealous eye.

Valentine never rebelled, never even expressed any complaint, any reproach, no matter how churlish and rough he was towards her. This meant he never had any hold on her, she escaped him like water running through his fingers, and he felt even more alone with his rage, with that irrational limitless anger that had been snarling inside him forever. So, having failed to deliver him from this anger, Valentine had become the object of it; she concentrated the secret fury that tormented him, thereby building it up. He made her the butt, or rather the visible trembling embodiment of his own distress, just as the huge abandoned oven was its soundbox.

For it was true that he only shut himself up in this building some evenings in order to drink and shout his drunken head off. Perched on one of those high wooden chairs from which the workers in the past used to superintend the baking of the tiles by watching the colour of the fire, he would drain bottles of red wine. The chair was quite wobbly, with the same unsteadiness of the shadows pierced by the acid light of two storm-lanterns set on the ground. And soon he too was staggering, the wine heating his blood, stirring his dark thoughts like mud, and he would shout hoarsely and

bellow, giving vent to abusive language and enormous belches. He imagined he could see the fire that had been dead for years blaze again, and hear it roar, leaping from one chamber to the next; hear it laugh and shout in the brick tunnel. When his bottles were empty he would throw them at the mouth of the oven; he enjoyed the sound of shattering glass, and all these scattered shards like spittle sputtered from the throat of the oven. Strange figures emerged from the gloom, grotesque fluctuating forms that he would set spinning round on the walls by swinging the lanterns. He spattered his darkness with splashes of harsh light, his angry outbursts like the raucous cries of rutting stags. Such was the theatre of grimacing and riotous shadows where he staged his boorish distress.

It was Arthur who broke the news of Anna's death to Valentine, or rather bludgeoned her with it.

'The lovely lass has killed herself riding her horse down Lovers Lane, popped her head off like a champagne cork!' And he burst out laughing. He loathed that insolently beautiful woman, who had the gall not to be afraid of him, who never lowered her eyes or her voice in his presence, and who came breezing into his house for a chat with Valentine. He was jealous of the affection the two women shared, of their secret conversations, their luminous laughter. In fact every time Anna visited Valentine, he would row with his wife afterwards, insulting Anna, Theodore, their brat Tobias, along with every other member of the Lebon family but especially the tribe from Poland, which he described as shit from the arsehole of Europe.

Valentine stared at him wildly when he trumpeted this senseless piece of news, and he added in a voice quivering with cruel delight: 'You see, Tine, you're both the same now, the tall lass has lost her noodle, just like you! But she's gone and lost it with a vengeance.'

So too did Valentine; she lost the power of speech, and her mind was completely unhinged. She could only stammer out sounds like an infant learning to speak, 'ma ma ma ma . . . ' With a lipstick that Anna had given her one day, saying, 'this is to brighten your storytelling mouth', she began to smear not her mouth but the reflection of it in mirrors. She had lost her face; it had detached itself and now floated in mirrors, on windowpanes. Every time she caught sight of her face, she would call out to it in those meaningless words of hers, comically waving her hands in the air, and laughing, a little broken laugh of deplorable sadness.

'God will never cease putting me to the test,' Deborah would say to herself, 'but he has also given me singular powers of endurance.'

Then she would reflect and wonder if her strength and longevity were not more of a scourge, an extra tribulation, than a matter of good fortune. Now at the age of ninety-three she had to look after a five-year-old child while all those belonging to the generations in between were dead and gone, or stricken with madness, with paralysis.

'What am I then in the eyes of God that on the one hand He crushes me and on the other He spares me?' she asked herself.

And in her now completely cracked voice she would sing to Tobias the songs in Yiddish that she once sang to her daughters, then to her grandchildren. For one last time, she bequeathed a little of her memory, a few relics of a past life. She still set up the Sabbath table on Fridays, in the drawing room where Theodore had taken up residence since his return from the convalescent home. He could no longer climb the stairs, and in any case, even if he had been able to, he would not have wanted to sleep in the room where he had spent so many nights with Anna. A divan had replaced the sofa, the wing-chair had been thrown out and another, more

squat, now stood by the fireplace. Deborah was the only one who sat in it, Theodore had his own chair, a wheelchair.

Laying her hands, which had become more gnarled and creviced than old bark, first on the father's white head, then on the son's very curly head, Deborah would recite the prayer: 'May God liken you to Ephraim and Manasses;' but sometimes her memory played tricks on her, time suddenly retreated and Deborah thought she was back in the house where she had lived with Bolko, Rosa and Violette, and she said the words reserved for her daughters. 'May God liken you to Sarah, Rebecca, Rachel and Leah.' But no one took offence. Theodore was immured in his grief, Tobias participated in the ceremony as if it were a solemn and beautiful game, the staging of a story whose meaning escaped him but whose words undulated with the candle-flames. So, Ephraim or Rebecca, Manasses or Leah – it made little difference. Then Deborah chanted the *Shalom aleikhem* to welcome the sabbath angels who were supposed to accompany the faithful home from the synagogue. Here too, ritual was violated; neither Theodore nor Tobias were circumcised, and in any case no synagogue had ever been erected in the marshlands. But so it had been for more than seventy years for the God-fearing Deborah, who every Friday had to invent an imaginary *shtetl*, an invisible synagogue, and never gave up inviting angels to her table. Then came the blessing of the bread and wine, and after dinner the prayer of deeds and graces.

Tobias would make little balls out of breadcrumbs, and with a discreet flick of his fingernail send them rolling over to the drops of wine that, just as ritually as the prayers unfolded, his father would spill on the tablecloth whenever he raised his glass to his lips to drink a sip.

Theodore had only the use, the clumsy use, of his left arm, and his mouth remained twisted, his lips drawn back and rigid on one side. Tobias watched his pellets turn red, the candles drip and form little translucent puddles on the tablecloth,

Deborah's knotted hands with their wrinkled and speckled skin, the wine stains dribbled on his chin and shirt by his staring-eyed, wry-mouthed father, and he wondered what on earth angels looked like, those guests so regularly invited, so patiently awaited, but who never came and sat with them. And he was a bit cross with them for being so slow to answer the summons, just as he was cross with his mother for being away so long, her absence not to be reckoned in days, or months now, but already in years.

Tobias did not understand grown-ups; one minute they were there – as they had always been, loving and smiling – and then all of a sudden, without any warning, they disappeared, like floating clouds in the sky which a gust of wind rising from the sea would carry off at crazy speed, snatch from view or else so distort they became unrecognizable. His father was all disjointed, rasping inaudible words, with a lopsided face, his mother had vanished, and his aunt Valentine had turned into a puppet capable only of mouse-like squeals. As for Deborah, she increasingly resembled one of those stubborn ash trees that grow askew on the banks of canals, their trunks all knobbled and cracked, with twisted roots plunging into the greenish water; but he had always known her, at least, to be just the same, like gnarled wood, and in fact she was the only person he trusted.

By contrast, his father now inspired him with nothing but wariness, fear and fascination. For there was a duality and total unpredictability about this father of his. Half-dead and half-alive, half-mobile and half-paralysed, sometimes silent and sometimes erupting, it was impossible to know which of his two sides, the diurnal or the nocturnal, the gentle or the violent, was going to prevail.

He could remain prostrate for hours on end and the earth itself might have trembled beneath his feet and he would not have batted an eyelid; he could even spend entire days in bed, lying on the divan like a recumbent effigy, staring at the ceil-

ing. But when he was animated, more often than not he would display brusqueness, become vexed by his own clumsiness, knock over things that he tried to pick up, and make those guttural noises.

Sometimes, however, a rush of that tenderness with which he had been so lavish before the accident would sweep over him again, and he would try to make his voice sound less harsh, so that it became plaintive, almost imploring; he would call for Tobias. He would call him as one begging forgiveness, and the child would approach him, with bated breath, his heart pounding. Theodore would raise his left hand to his son's head, stroke his hair, and his trembling fingers would brush his face, and in his eyes there would be an expression of great gentleness – a gentleness devoid of any joy, a catastrophe of love, while his mouth tried in vain to form the faintest of smiles. Tobias would clench his jaw so as not to scream, or cry. He felt such pity, such confusion before this broken, exhausted father, and such shame too. These caresses from this half-dead man terrified him more than anything else because they distilled within him, like purulent tears that made him feel sick at heart, a little of the horror, of the insane grief his father was prey to, and yet he could not offer him any comfort..

There were other times when Theodore, in a fit of rebellion against the chasm of grief yawning inside him, against time that refused to pass, would rear up out of his chair and, staggering to the middle of the room, shout his son's name in a choked and yet deep and menacing voice; he would call for him as if a river, a valley separated them. Tobias would run to take refuge in a corner of the drawing room, he would curl up and hide in a cupboard or under the table. But then his father's fury would rise to a pitch, he would whirl round like a spinning-top losing its balance, stumbling, bumping into the furniture, and finally, supporting himself against a wall or against the chimney-piece, he would strike his own face with

his good hand. His arm would rise like a whip, alien to the body to which it was attached, and deliver a hail of blows.

Tobias would close his eyes, press his fists close to his ears so as not to see, not to hear, but the blows with which his father assailed himself, uttering cries interspersed with groans, reverberated in his body, resounded in his head, in his stomach. And rushing from his hiding place, he would come and throw himself at his father's knees, put himself within reach of that hand. He would wordlessly surrender to those slaps, shielding his face with his arms, because the blows he received were less painful to him than those his father inflicted on himself. And these slaps caused him less suffering than the pitiful mortifying caresses that his father sometimes bestowed on him. His father only hit him because he, Tobias consented to it. In this obscure confrontation their two bodies became one, complementing each other. They then formed the one same flesh, a joint anger, a joint grief. It was an ordeal they shared.

And then, in those moments, Theodore would stand upright, and his thinness would make him seem even taller than he was, and above all he would fight. For the child was well aware that the fit of violence that overcame his father was not directed against him, Tobias, or indeed against anyone in particular, but against something much bigger that had no name or shape, no face, nothing. And it was precisely against this nothing, this terrible nothing, so tenacious and cruel, this nothing endlessly perpetuated by death, that Theodore endeavoured to fight against. But how was one to fight against emptiness, absence, the utmost unhappiness? Tobias offered himself as a substitute every time his father declared war on this deadly nothing, challenged to a duel this grief that kept defying him by refusing to be appeased. Tobias offered himself not as a victim but an adversary, a compassionate enemy, whenever the need arose.

It sometimes happened too that Theodore, rousing after being laid low for a long time, would ask Tobias to bring him a book. The child would keep repeating the title of the work and the author's name for as long as it took him to search through the bookcase that lined the wall of the upstairs corridor. He would climb on a chair, examining the shelves. The smell of the tightly packed books, a sweetish smell of decay, of dust, made him feel slightly dizzy. At the ripe old age of nine, he remembered that his mother used to read to him every evening from a little illustrated book. She would sit on his bed, and he would rest his head against her shoulder, and let himself be lulled by her voice, by the warmth of her body, by the fragrance of her throat. They were lovely stories, their simple words enhanced by pictures coloured like sweets, and it would all melt in his mouth, under his eyelids, and he would fall asleep with this taste. But those happy days of fairy tales had suddenly come to an end, both in his room at bedtime and at Valentine's white house. Other days had succeeded them: days when Deborah, in that cracked voice in which her foreign accent still lingered, told him stories more fraught with darkness, with snow and earth. Fairies, princes and princesses had no place in them; the animals were not magic, they came straight out of farms; and water-carriers, goatherds, rabbis, coachmen and village idiots figured large. Yet great wonders occurred in them too, and it was not so much the earth passing itself off as heaven, but rather heaven coming down to earth to take part in the dramas, dances, celebrations, and songs of all those humble folk in their muddy rags, with hearts as pure as spring water and as big as the rising sun. But Deborah filled her stories with expressions unfamiliar to Tobias and she almost always ended up speaking completely in Yiddish. Then the stories turned into melodious incantation, just like the sabbath prayers, or the clamour of birds at the beginning of spring, or the sound of the river when the waters were high. A

71

voice rising from the depths of the earth, the clay, the depths of time – an obscure background noise on which Tobias had to graft words of his own language to concoct some sense out of them, not to let himself be dazed by this slow avalanche of sounds.

And words, the seeds of dreams, he found in abundance in the books that his father sent him to look for. For Theodore, who was quickly tired by reading, often asked Tobias to read some pages to him. Seated on a stool in front of his father, with the book open on his lap, the child would strive to read, scrupulously following the lines with his index finger so as not to miss out a word, but he would often stumble, mispronouncing words because he did not understand them, and Theodore would sigh with growing irritation, even interrupting the session with an abrupt wave of his hand when the reading became too annoying. Upset by this, Tobias would take the book away with him, but sometimes he would open it again, and huddled on the bottom stair in the corridor, he would start reading aloud, under his breath, just for himself, the passage he had bungled, especially if it was a poem. And some of the poets particularly caught his attention: among them, Saint-Jean Perse, because of the silky sonorousness of his name, and even more because of the ampleness of his phrases, the ponderous tide of words each more extraordinary than the other. And what amazed Tobias, was the contrast between the brevity of the titles – Eulogies, Winds, Landmarks, Exile, Chronicle, Birds – and the unfurling phrases from the very first page, that enormous swell, full of roaring and shimmering and whistling.

'O you, desire, that are about to sing . . .
 And is not my whole page already rustling
 Like this great magic tree beneath its winter squalor: vain of its share of icons, of fetishes,
 Cradling relics and spectres of locusts; bequeathing, binding

to the wind of heaven descendencies of wings and swarms, relations and correlations of the most high Word –

Ha! great tree of language peopled with oracles, with maxims and murmuring a murmur of the blind-born in the quincunxes of knowledge . . .'

All this, or nearly all of it, eluded Tobias, but he nonetheless derived a bewildered pleasure from it, it was powerful and warm as summer rain. And then occasionally he would look up in the dictionary the odd word that intrigued him more than the rest, whose sonority pleased him, and he was often thoroughly confounded by the definition of a word to which he had already given a completely different meaning, that had nothing whatever to do with it.

There was also Verlaine, some of whose verses lingered within him long after he had read them, like trails of mist clinging to hedges, to bushes, or like gossamer-threads streaking the grass with fine glints of silver: something impalpable – a haze, a quiver – and yet resistant to the wind, to darkness, to oblivion.

So Tobias developed a relish for words, and curiosity prompted him to go and rummage through works other than those his father asked for. What did all these books left lying on the shelves have to say? Tobias suspected that secrets slumbered in these pages abandoned to silence, or rather he yearned to discover other landscapes in print. But most of the time he would close the books he had secretly removed from their dusty slot and skimmed through, disappointed, unsatisfied; they were too difficult and did not make the words stir or resonate. One day when, with nothing better to do, he was combing the shelves in this way, he took down a book that had the effect of stinging nettles on him. It was a slim volume bound in darkly-marbled grey, with yellowed corners. In huge brown letters was the name of the author and the title:

Gottfried Benn – Morgue. That word he knew, indeed it had long been lodged within him – his mother's body had lain in a morgue before burial, while the investigation into the bizarre decapitation was conducted. And besides, had his father not turned into a morgue himself, where half his own body and the mutilated corpse of his wife lay?

Tobias opened the volume and from the very first page experienced, not even an emotion, but a shock, a dark bedazzlement. And he read, and reread – a reading that was more like a mastication, there were so many difficult phrases that needed to be chewed over, ground down, in order to extract their bitter beauty, so many raw images to swallow:

A drowned sot, the driver of a beer truck,
was hoisted on to the slab.
Someone had jammed a twilight-lilac aster
Between his teeth.

And this little aster began to twirl round, to turn different shades of blue in Tobias's imagination. What flower had grown between his mother's teeth? Who could say? His mother had hidden her head in a place impossible to find.

One quatrain of the poem 'Requiem', describing the corpses of men and women with their skulls and torsos split open, gutted, became a catechism to him:

Each one three bowls full: from brain to testicles.
Both temple of God and Devil's sty
now face to face at the bottom of a bucket
sneer at Golgotha and the Fall.

Another poem served as an anatomy lesson:

I roar: spirit, reveal yourself!
The brain rots just like the arse!

Already the gut is belching fraternally –
already poor Cousin Scrotum is whistling familiarly!

Morgue. Every poem was like a dissecting table on which lay
carved-up rotting bodies, some harbouring nests of rats under
their diaphragm, others flies in their slimy guts, young women
with blue-tinged foetuses in their wombs, and all seeping
blood, lymph, pus.

Morgue. And the cadavers became cantors of great lyricism
and bravura. One cadaver sings: 'Soon fields and vermin will
overrun me . . .' And their songs were his companions, he let
them resound in his head at random when his father grappled
with his own misery and struck out at him on the rebound.
Their irony and blasphemies sustained him when his father
assailed him with the burdensome grief of his caresses. And he
silently recited their grim lines as Deborah wove a back-
ground of sound, spinning her tales and legends in the lan-
guage of her forefathers.

Morgue. Each poem like a tuft of stinging nettles in the
hands of the child huddled beneath the corridor ceiling, a
fistful of embers in his orphan heart. And one poem was more
searing than any other. Its title was of immense restraint:
'Mother', and it became Tobias's night prayer.

I bear you like a wound
on my forehead that will not close.
It does not hurt all the time. And my heart
is not flowing to death from it.
Only sometimes I am suddenly blinded and taste
blood in my mouth.

Morgue, this word became confused in Tobias's mind with
that of library, each book possibly turning out to be a show-
case of phrases and terms not yet identified, not understood
by him, a dissection room of language. And from the belly of

words rose amazing images, flowers and thistles sprang from the entrails of sounds. And his mother's body kept endlessly recomposing itself from all these fragments, a vast jigsaw puzzle with an abundance of ever-moving pieces but at the same time with a key element needed for its completion missing. A body to reinvent, to reassemble day after day.

Tobias's world was confined to the marshlands whose every nook and cranny, every secret and charm, he was familiar with, and to his father's library which he secretly transformed into a fantastic morgue. An event occurred that brought about a certain disruption in his imagination and vision of the world. It happened during an outing organized by his school; he was invited with all the pupils in his class to spend the day at La Rochelle.

They set off in high spirits, the children making a lot of noise on the coach. From time to time the teacher told them something about the places they were passing through. When they came in sight of La Rochelle he told them that a beached whale had been washed up two days before on the coast of the Ile de Re, just opposite the road on which they were travelling. A stray whale, perhaps sick or grieving – no one really knew where it came from, or how or why it had chosen this place to die. Tobias's imagination was immediately fired, and when he got off the coach he thought he detected in the air the smell of dead meat, of rancid fat, carried on the sea breeze, and he pictured to himself an enormous whale, its loneliness and distress beyond all measure, tragic in its death and stench. And he felt great pity for the animal cast up by the ocean, abandoned on the shore, bereft of its magnificence, its strength, its songs.

They briefly wandered through the town, whose whiteness enchanted Tobias, then the teacher took them to the port of Les Minimes, with its forest of swaying masts; but Tobias thought of a bank of reeds rather than a forest; not quivering

and rustling like those of the marshlands but jingling. And the ocean, which he beheld for the first time, stretched beyond the masts as far as the eye could see.

In the morning they visited the aquarium, in the afternoon the natural history museum. All the children were filled with wonder by the aquarium, and they enjoyed the museum. They admired Lafaille's cabinet with its glass panels ornately framed with fluted pilasters in shades of yellow ochre set off with crimson, displaying birdcages, tortoise shells, and bizarre seashells, some intricately carved; suspended from the ceiling was a crocodile, a barbarous presence poised above a piece of furniture of extreme elegance and some curious marine trophies, along with the skeleton of a dolphin.

Then they came upon the cream-coloured red-spotted giraffe that an Egyptian pasha sent as a gift to King Charles X of France. The giraffe, still very young at the time the gift was made, and which had to be fed with the milk of three cows during its voyage, came by sea and arrived at Marseilles. It was led with great pomp along the roads of the realm to Paris. After more then seventeen years on French soil, in the course of which the last of the Bourbons fell from power, the giraffe died without issue. So, two dynasties came to an end. The giraffe was stuffed, but not the ousted king, who went into exile. What was the point of stuffing him? That dull little king had always been a man of straw.

Continuing to travel even after its death, the giraffe came to display its exotic beauty in La Rochelle, and there it now stood on a staircase landing, among other stuffed animals and some splendid antelope and gazelle horns, its gentle black eyes frozen, yet its vacant gaze still filled with poetry. On the wall just above its head floated a shadow crown projected by a cylindrical chandelier.

It was on the first floor that the visit he had so far enjoyed upset Tobias's cheerfulness. Up there too were numerous birds, monkeys, wild beasts, as well as some unusual objects,

but one case captured Tobias's gaze, and at once clutched at his heart.

This case was entitled 'Cult of the skull'. Displayed in it were skulls daubed with brightly-coloured clay and decorated with pearls, statuettes of grimacing beauty, and some heads. One of these heads was all blackened and reduced to the size of an egg; another, that of a Maori warrior, was mummified and tattooed, its mouth twisted in a cruel, or painful, smile. Tobias was violently shocked by these faces; the brown skin hardened like old drums, the skulls covered with hair like tarred oakum and the eyes with lids opened like gashes on their sightless gaze, or rather on the frantic madness of second sight. He betrayed nothing of this, while his friends guffawed at this display case; they would have made fun of him if he had revealed his emotion.

They could laugh themselves silly, these cut-off heads meant nothing to them, reopened no wound, revived no grief; only he had a mother whose head had been sliced off and stolen.

Then he was assailed with his father's anguish: Where then was his mother's head? In what state was it? Was it covered with obscure signs, cracked and shrunken to the size of a desiccated apple? Had it been stolen to be exhibited in a museum, displayed behind glass, like these ones? Were children sniggering and joking at her mummified face? Tobias felt like screaming, smashing the case, taking these heads that had been torn from their bodies and deprived of burial, and covering them with earth. And tears of rage and rebellion came to his eyes. Misted with anger, his gaze then lighted on a statuette he had not noticed before, and all of a sudden his fury died away, without his understanding why.

It was a small brown wooden sculpture gleaming with orange-red reflections, representing a two-headed individual. Set on a single body were two identical heads – with strong features, long aquiline nose, round eyes with obsidian pupils

brilliantly inlaid with bird bone, open mouth, and prominent chin graced with a goatee beard in the shape of a comma. But this single body was no less twofold, for it combined the sensuality of a living person with skeletal thinness – its ribs were meticulously carved out in relief, as was the vertebral column. Half-dead, half-live, this body held its two heads slightly bowed, their naked skulls engraved with similar designs.

The statuette came from Easter Island, it bore the enigmatic name of 'moai kavakava'. It held Tobias's attention for a long time; he derived from its contemplation an alleviation of his grief, as if these two bowed heads addressed a greeting to him as discreet as it was fraternal, and above a message, one that was unclear but comforting. This little two-headed character seemed to defy death, at least to have tamed it, to have quietly made it part of life, while the mummified heads grimaced threateningly. Tobias told himself that a second head might have grown in place of the first on his mother's shoulders; a head with mineral eyes, wide-open under the earth, and smiling a peaceful smile.

The name of 'moai kavakava' engraved itself on his memory, and silenced the grim, harsh verses of Gottfried Benn's poems; after his visit to the museum in La Rochelle, and his encounter with the statuette – for it was a veritable encounter that had taken place – Tobias gradually turned away from the 'morgue-library'. He felt the desire to work with wood, with clay, he sculpted a few figurines and made ships mostly, sailing ships, barges, even out of paper. The ocean entered his dreams; he wanted to become a sailor, to sail to Easter Island, the island of 'moai kavakava' and of the giant statues, that slab of volcanic rock set in the middle of the waters of the Pacific like a face raised in prayer to the immensity of heaven.

'God will have kept me alive on this earth a very long time,'

Deborah said to herself on her ninety-ninth birthday, 'but all the same he's going to have to end it sometime!' And from that day she prepared herself for death. It would have seemed indecent to her to live past a hundred. 'That's all very well for prophets, but not for me,' she thought. But the months went by and her heart, ever sturdy, stubbornly continued to beat quite regularly.

She even had a tremendous renewal of energy which she transmitted to those around her. Theodore finally started to recover, less often remaining prostrated, no longer giving way to those crises of despair that transformed his arm into a whip; he forced himself to learn to walk again, to speak. They were still extremely small footsteps, very stiff and uncertain, and short words, not easy to hear, but his world which for years had been enclosed within the drawing room walls opened up a little, extended into the yard, the garden. He ventured to confront the day once more, the sounds, smells, bright colours of out-of-doors, and to reconcile himself with this place which had been the scene of the tragedy. The hollyhocks, of white, violet, purple, blossomed every year, their soft velvet clusters swaying in front of the stone wall on which lizards darted. The midnight-blue peacock had placidly spent the time in between simply wandering round the yard, spreading its tail, emitting strident cries to break the silence, like reproaches addressed to heaven. Often towards evening Basalt the peacock would start up a long monologue like the singing of a saw, a haunting sound, at once plaintive and angry, and Theodore would listen as if this animal were his messenger, voicing his grief.

Deborah made herself busy; one day in September she decided to open up her house again, which she had not lived in for six years, and give it a thorough cleaning. With Tobias's help, she washed the floor tiles, waxed the furniture, weeded the yard, planted flowers. All this activity surprised Tobias, and

he asked her whether she wanted to let or sell her house, but Deborah said no, she was tidying up and cleaning because she was expecting a visit.

'Who's coming?' He wondered because, apart from the doctor and nurses who came regularly to treat his father, no one ever visited them.

His wonder turned to astonishment when the old woman told him in a cheerful voice that she was expecting the angel of death. Theodore had on several occasions asked Tobias to read a much more disturbing book even than the poems of Gottfried Benn – the Apocalypse. On every page arose angels armed with swords, with flame-throwing, hail-and-storm-and-flood-precipitating trumpets, in the tumult of which they directed armies of horsemen in armour of fire, jacinth and sulphur.

'And will he have a trumpet?' asked Tobias.

'Of course not, he'll be empty-handed, the angel of death is very discreet, he won't make any noise. And besides he won't need to wait, because everything will be ready.'

For decades now she had been ready.

'Can I see him?' asked Tobias.

'I told you, he's very discreet,' said Deborah, content to repeat what she had said.

'And when will he come?'

'When it's time,' she said, but in her heart of hearts she had set the clock so that the last chime should sound before she turned one hundred. Yet it was already autumn and her birthday was approaching.

It was Rosh Hashanah. One afternoon Deborah took Tobias with her down to the banks of the river called the Mignon; she did not throw crumbs into the river water, just a stone. A grey pebble veined with pale pink, the one she had picked up on the banks of the Lubaczowka around the beginning of the century, and had kept ever since. It was her sole possession, a

concretion of her past, her memory stone; she assigned to it all her sins, not only those committed during the past year but all those accumulated throughout her life. Actually a tiny piece of gravel would have sufficed, so meek had Deborah remained since childhood, so unshakeably true to her God, to the Law, to the earth, to each of her loved ones. Indeed the pebble dropped lightly, forming a few trembling rings on the surface of the water that glistened for a moment, then faded away. And as if the dropping of the pebble into the water had been a signal, a bird immediately took flight from the riverbank where it had been hidden among the tall grasses. It was a little egret of misty whiteness. It seemed to fly slowly. It gave a melancholy almost tender call, despite its croaking voice.

So as not to be left out, Tobias rummaged in his pockets, extracted from them a paperclip, an apple core, a hardened piece of chewed gum, and he threw the whole lot into the river. Three little circles undulated, blended together, and the water became still again. Tobias was a little disappointed that no bird greeted his gesture with a fine rustling of wings.

Deborah recited the prayers, then expressed the desire to be inscribed in the Book of Life. Tobias wondered what book this might be, he had never found one by this title in the bookcase in the corridor, but he dared not question Deborah, sensing how solemn and devout she was at that moment.

The water was reflected on their faces; for the first time Tobias studied the old woman's face really closely, and he found her beautiful, with her light-spangled wrinkles, her strangely limpid gaze beneath her crinkly eyelids, ringed with ochre shadow. Her gaze was like clear water springing from the rock, and he thought, 'That's the water sins should be thrown into,' all the sins of the world. But he lowered his eyes, too perturbed to sustain the transparency of that gaze.

They strolled along the river for a while, holding hands. Tobias had never realized how tiny Deborah was; he was only eleven, she was nearly a hundred, but he was a head taller. The

hand he gripped in his own was as fragile as a bird's foot, and frightened of hurting it he opened his fingers. Her whole body was sparrow-like, she did not so much walk as hop, hardly touching the ground.

It was a lovely evening. Their supper was simple, they dipped bread and quartered apples into honey. And Deborah sang that evening as Tobias had never heard her sing before; it was not that deep undercurrent of sound he had developed the habit of embroidering with lines stolen from poets here and there, it was a rising swell originating from the earlier part of the century and further back still, a clamour of stars in the night, a lament resplendent with pride and hope. Deborah took on much more than her 'candle voice' as her daughters used to say, she sang with the voice of one of the Just, weighed down by tribulations, worn out with love for the land of the living – for her, all her dead were still living – the voice of a mortal whose passing was imminent. She rediscovered the inflections of her father, Cantor Yoshe Rosenkranz.

Tobias could not contain his admiration.

Deborah said simply, 'It took me nearly a century to understand what my father often said, that to sing well all you have to do is get your breath from the soles of your feet, from the tips of your toes.'

Three days later Deborah celebrated the sabbath, still singing from the soles of her feet. It was as though the river water continued to cast light on her face, so luminous was she, and for Theodore and Tobias the brightness emanating from their aged relative outshone the lighted candles on the table. Their lives lay in the shadow of this woman, of an entire people, and the perpetual singing of a book, the only one Deborah had ever read.

Deborah did not muddle up the blessings this time, but she invented a new one. When she came to Tobias, she said, 'May God liken you to Mejdele.' No one knew who Mejdele was,

Deborah had always kept this name secret, she had never spoken of her vision in the middle of the Atlantic, nor of her long confrontation with the carved lamb on the church's altar. So Tobias did not grasp the meaning of this phrase, just as he did not understand what ceremony Deborah was conducting in the very midst of the sabbath ritual. A farewell ceremony.

The following evening she returned to her house. She left the key in the lock, outside, and she opened wide her bedroom window. She washed, put on a white cotton nightdress, lay down in her bed, and waited, with her eyes open. It was raining, a slow grey autumn rain. The smell of earth and wet leaves came into the room.

The rain stopped towards the middle of the night. Silence spread over the earth, through the house, punctuated only by drops of water falling from the roof and leaves. A bluish darkness bathed the room.

The angel of death passed by at dawn, made no sound and did not linger.

So, even Deborah had betrayed his trust? Tobias could not believe this desertion. He went to the house where the dead woman lay, he began by inspecting the ground around the walls, to see if there were any traces of footsteps, those of the angel she had invited. He was prepared to wrestle with that angel to force him to give back to Deborah the breath he had stolen from her. But he discerned no trace, either outside or inside the house.

He went into the bedroom. The shutters had been closed, a little daylight filtered through the slats. Deborah was lying on her bed, wearing her nightdress, her hands crossed on her breast. She seemed to Tobias even tinier than before – a bundle of bones held together by boiled and cracked leather. A gauze band was tied round her head, encircling her chin, cheeks, temples, and Tobias wondered why she had been dis-

guised as an Easter egg. Then he realized he was for the first time in the presence of a corpse, and the most brutal lines of Gottfried Benn's poems still lurking in a corner of his memory came back to mind:

Corpses.
One puts a hand to its ear:
What, you're shivering? On my heated dissection table?
Because of fat loss and biblical age?
A child's corpse in your face, more like!
Arthritic joints and worn-down teeth
carry no weight here!
Just lie there quietly on the ice!

He shook his head fiercely to chase away these shrill words that assailed him like crazed flies, then came and stood at Deborah's bedside, bent down over her curiously shrunken face, the colour of dried clay, closely observed her eyes in the hope that her eyelids were going to open and reveal the limpid gaze that had so dazzled him a few days earlier. But they seemed welded together. He checked the state of her neck, to reassure himself that it had not been cut, that he would not be robbed of her head too. Then he walked round the bed, stationed himself before the recumbent body and examined its feet; they were bare, as thin and knotted as the hands. He thought again of what Deborah had said, about having to sing from the soles of your feet, and he put his ear right up against them. Maybe he would detect a murmur, an echo of the songs she chanted, a trace of her voice caught at the very source? He held his breath, and closed his eyes the better to concentrate and to sharpen his hearing. The feet were freezing cold, and silent.

He suddenly straightened up and returned to the dead woman's bedside. For he had another question to ask her: who was Mejdele? How would he manage to be like Mejdele

if he knew nothing about this model she had very solemnly given him? Was it a man, woman, prophet, child, shepherd, king or warrior? Then it occurred to Tobias to untie the gauze band wrapped round her shrivelled head, so as to free her lips, and trembling as he untied the knot, he asked his question under his breath: 'Tell me, who is Mejdele? How am I to be like him?' The only response he got was a grotesque and horrifying vision: the old woman's jaw dropped open and her dentures jumped out of her gaping mouth like a little jack-in-the-box, and rolled on to the sheet.

'She's broken!' screamed Tobias, and fled from the room.

Deborah Rozmaryn, nee Rosenkranz, was buried in the cemetery the day before she would have celebrated her hundredth birthday. The number of years she had spent on earth far exceeded the combined total of Bolko, Violette and Rosa's three lives. Three lives, the burden of whose absence she had never ceased to carry. But three lives that, through her, finally obtained burial. Theodore, to whom Deborah had entrusted the terracotta pot still containing the medallion of the Virgin, the milk tooth and lock of hair, instead of a handful of earth threw these three relics into the grave, where they were immediately covered up with shovelfuls of clay.

In the days following Deborah's burial a strange phenomenon occurred: water began to seep from the earth around the tomb. Drop by drop the water rose to the surface, glistened in the grass, then thin rivulets formed, grew bigger, spread into puddles, and the puddles into a pool. Floodings are of course to be expected in the marshlands, but they have their season, and they result from rivers being swollen, whereas in this case, it was the earth that was leaking, discharging water whose source was inexplicable.

The source was nothing other than Deborah whose body exuded one by one the tears she had for so long held back: her body wept and wept, unburdened itself of immeasurable grief, purged itself, bathed in the avowal of its sorrow.

Tobias often visited the cemetery. He would go from his mother's grave, as yet a simple mound with a cross above it, to Deborah's, set a little apart, covered with no more than a completely stark slab of light grey stone, the inscription of her name and the dates indicating the length of her sojourn on earth not yet having been carved on it, and with no religious symbol adorning it. It was like a little island in the middle of a miniature lake, a closed eyelid rimmed with tears. Tobias wished he could pray, but did not know how, he jumbled together lines lifted from various poets with snatches of the prayers Deborah used to chant, but their meaning escaped him.

He started reading again, searching through the bookcase, always hoping to find, at the back of a shelf, the Book of Life that Deborah had mentioned, but it was not there. However, he did find a poem that helped him to overcome his hesitations and put an end to his incoherent mumbling when he wanted to address his mother and Deborah.

Mother, I'm no good at looking for the dead,
I get lost in my soul, with its steep faces
Its brambles, its watching eyes . . .

I speak harshly to you, mother;
I speak harshly to the dead because you have to,
Standing on slippery roofs,
Through megaphone hands in an angry voice
To overcome the deafening silence
That would keep us apart, we the dead and the living . . .

He wished he had written these verses by Jules Supervielle, he felt them to be so apt, so true. The silence stretching between the dead and himself was so heavy, vast and impenetrable, it had to be disturbed, breached. He would then climb up a tree, almost to the top, and clinging to the trunk shout at the top of

his voice, calling now to his mother, now to Deborah, and beyond these two women for whom he bore a love that did not accept the law of 'nevermore', he also addressed those men and women he had not known, who had preceded him. He defied the silence, the invisible, and even though he never received any reply, he did not give up hope of being heard.

Towards the end of autumn a strong wind blew in from the sea, chased cohorts of clouds high up in the pewter-coloured sky, and sea birds carried in by this air current came and mingled their rasping cries with those of the ducks and rooks in the marshes. The pool was covered with ripples. One morning Tobias brought his entire fleet to the cemetery and set it afloat on the water encircling Deborah's tomb. The little boats patrolled round the tombstone. Tobias had found his prayer, had found too his Easter Island – a slab of stone between water and sky, where amid great mystery the very face of memory, of patience, kept vigil.

Slowly the tears ebbed away while all around streams and rivers burst their banks and flooded the fens. The winter sky vibrated with crystalline light endlessly reflected by the water-sheeted frost-coated earth. The fleet was stranded in the short grass. Tobias's childhood lay there, in a circle, round her who had taken care of him and who would for ever remain the melodious deep undercurrent of his memory.

And the seasons slipped by, settling in layers of noisy birdsong, babbling water, rustling reeds and foliage, sighing winds, and fraught with his father's silences, which were always punctu-ated at twilight by the peacock's anxious cry.

And in the loam of time, still curled up and folded in on itself, desire started to grow in Tobias. Desire for a new life, desire to confront the world's ruggedness, the test of reality, the tales and fables of his childhood, Deborah's obscure

songs and prayers, the texts he had read, the dreams he was weaving.

'O you, desire, that are about to sing . . . The Narrator climbs the ramparts. And the Wind goes with him. Like a Shaman in his iron bracelets: Dressed for the aspersion of new blood, in heavy robe of midnight blue, crimson silk ribbons, and long folds of a mantle weighing next to nothing. He has eaten the rice of the dead; he lays claim to their cotton shrouds for his own use. But his words are for the living; his hands for the basins of the future.'

SARA

That day she was deeply grieved in spirit. She
went in tears to an upstairs room in her father's
house with the intention of hanging herself. But
she reconsidered, saying to herself: No! People
would level this insult against my father: You had
only one beloved daughter, but she hanged her-
self because of ill fortune . . .

In the very moment that Tobit returned from
the courtyard to his house, Raguel's daughter
Sarah came downstairs from her room.

The Book of Tobit 3: 10 and 17

It is an evening like any other, the swallows, golden plovers, warblers, lapwings, just returned from their winter exodus, sing out their joy to be back, their ever renewed eagerness to build ephemeral dwellings of moss, twigs, straw and mud. Theodore stands in the yard, a grey-blue figure barely distinct from the deepening violet-blue of the hedge. As still as a tall burned bough, he catches the last glimmers of sunset, with a mite more intensity, and heartache, than the foliage that surrounds him. He breathes in with the evening air the memory of Anna's hair, weighs in his palms two heavy clusters of lilac, the oh so gentle weight of Anna's breasts. And he wishes with the utmost fervour at that moment to dissolve into the darkness, at last to be released from life, relieved of his body, of his grief-stricken memory, to return to dust. But he lets go of the branch of lilac whose white clusters sway gently at the level of his brow, he grips his walking stick for support, and sighing, crosses the yard, and returns to the house. Tobias appears on the threshold, waves and smiles at him.

At the very same time, in another house built on the edge of a cliff, overlooking an estuary, a young girl named Sara emerges from her upstairs bedroom, goes rushing downstairs, a swift black figure in the tawny aromatic gloom of the staircase, and the smell of the tears bathing her face overcomes the smell of wax from the wooden banister. She weeps for shame and for the curse upon her. She too wishes at that moment to be forever released from earth, freed of her baneful body, of her deadly beauty. She would have killed herself, but she lost her nerve at the last moment, her deliverance would turn into hell the lives of her father and mother, Ragouel and Edna, of whom she is the only and much loved child.

Her hand slides down the banister, her bare feet trip noise-

lessly from one step to the next, and her streaming hair hangs loose about her face, a very pure, sharply defined oval, with shining eyes the deep violet colour of irises. Three beauty spots set off the whiteness of her complexion: one on her cheek, under her left eye; another at the base of her neck, above her collar bone; the third is concealed near her right breast.

She has no use for her youth, gracefulness and radiance, or rather she has a horror of them. Her beauty is a scourge that seven times already has brought death. And now people look on her as a plague-carrier, a witch, especially mothers with sons who have reached the age of desire. That very after-noon the woman who had been their housekeeper for years informed her mother that she was handing in her notice, that she did not want to work any longer in a house inhabited by a young girl who behind that hypocritical demeanour was cap-able of such evil.

'That Sara of yours should be locked up in a bunker, so that no one can see her any more, and above all can't get close to her. She's as dangerous as that radioactive waste that kills any-thing unlucky enough to come anywhere near it!'

Sara heard the woman hissing these angry words between her teeth. The flames in which so many young girls and women were burned at the stake for deeds of black magic in the vicious days of the Inquisition crackled in her accuser's voice, and those flames blazed in Sara's heart. She ran to hide in her bedroom, and cried for a long time; her mother, who went up after her, was unable to console her. The flames writhed inside her; although she was innocent, Sara gradually resigned herself to expiating the crimes attributed to her. When her mother left her on her own, she resolved to kill herself, locked the door of her room, took down the draw-cord from the window-curtain, tested its resistance, tied a running knot in it, then stood on a chair, and hung the cord

from the light hook. She climbed down from the chair, sat on the end of her bed, and gazed up at the noose.

In the noose's oval frame seven faces appeared, one after the other: the faces of her victims. She was certainly not guilty of killing them, she had not plotted or committed any murder, or even wished it on anyone, but in some inexplicable way she was nevertheless responsible. She sensed it, she knew it, she declared herself to be the cause of these sudden deaths. For when accidents occur too often, with too much similarity, it is no longer curious coincidence that is at work; chance eventually proves to be a law no less mysterious than implacable, and in this case, the accidental bore every resemblance to inescapable doom.

It all began on the day she turned thirteen. Her parents had organized a birthday party and Sara had invited a number of her schoolfriends. One of them, a boy of her own age, taking advantage of a moment when he found himself alone with her in the corridor, kissed her on the mouth. Emboldened by this stolen kiss, he then started playing the buffoon, clowning around and showing off, and when the birthday cake was set in the middle of the table, covered with a tablecloth printed with brightly-coloured flowers, and Sara had blown out her thirteen candles, the boy grabbed the big crystallized cherry decorating the cake, like the pompon on a French seaman's beret, waved it aloft in triumph, then, tossing it up in the air, with his head thrown back, mouth open, he swallowed it. He then started gesticulating comically, gasping and croaking. The others continued to laugh, thinking this was another joke, but our comedian was not acting any more, the sugar-coated glacé cherry had quite simply gone down the wrong way, and he was choking.

He suddenly collapsed at Sara's feet, as she stood holding a little silver cake-slicer in her hand. And there he died, in the middle of the party, his neck swollen, his face purple, before

Sara's bewildered eyes. As she blew out her thirteen candles, had she with the same murderous breath dispatched her thirteen-year-old classmate?

The following year she had a holiday flirtation with a boy of fifteen; one afternoon on the beach they exchanged a kiss. And the boy had immediately been seized with a desire to run into the sea, and he dragged Sara along after him, uttering great cries like a soldier mounting an assault. But the waves were high and buffeting, Sara took fright and stopped at the water's edge. Indeed the lifeguards superintending the beach had raised the black flag, and Sara pointed this out to her friend. He did not care, he was too exhilarated, and went rushing into the sea, laughing.

Sara, who was left standing on the shoreline, called out to him, but the thundering of the waves drowned her voice. A roller caught the reckless youth off balance, overturning him, engulfing him, then the wave came in and broke round Sara's knees, then receded to gather itself up again, and again, and again. But the boy did not reappear. It was not until the next day that his body was found.

A year later, another kiss granted to a young man who had been courting her for some weeks led to a similar scenario, just as absurd, just as tragic. After having kissed her, the young man was bursting with joy, with vitality. Since they had kissed beneath a pine, he took it into his head to go up and fetch the cone that was hanging from the highest branch; he wanted to keep a souvenir of that first kiss, a souvenir to match the exalted happiness he felt at that moment. To dissuade him from climbing the tree whose tall and slender trunk made her head swim, Sara picked up a huge, lovely russet-brown pine-cone, lying on the ground, and offered it to him. But the gallant lover scorned this too easily acquired trophy, he wanted to get hold of the one at the top of the tree, to defy the inaccessible, and he launched himself at the trunk like a cat, finding finger-holds in the cracked bark, and made a rapid

ascent. Half-way up he lost his grip and his balance, and he fell, not with a cat's litheness but with the heaviness of a man falling some fifteen metres. And he crashed to the ground, carpeted with slender pine needles, right in front of Sara, whose hand contracted round the pine-cone's open scales, causing abrasions to her palm.

And it was that day when the first doubt entered her mind, when she began to establish a link between the three accidents that had occurred since her thirteenth birthday.

So, when a young man later courted her, becoming increasingly insistent, and impatient, Sara confessed to him her fear, why she was afraid. But her suitor laughed at her story, which he judged absurd, even suspecting that the young girl had concocted this tale in order to give herself a greater allure of mystery and to keep him languishing all the more. So he disregarded Sara's apprehensions and without further delay kissed her. And as he wanted to prove to Sara that the fears tormenting her were nothing but the fruit of her imagination, he held her close and swept her along in a manic waltz, singing at the top of his voice.

At last, out of breath, he released her from his embrace, and proudly declared, 'You see, everything's all right, there's been no catastrophe. From now on, I'll kiss you as much as I like!'

True enough, nothing happened, at least not straightaway, and Sara regained confidence. But during the night following this brief amorous interlude the young man was overcome with violent headaches, fever and vomiting. In the morning his parents had him taken to hospital; he was diagnosed with meningitis. It progressed at a galloping speed, the young man died the same day.

From that day on, Sara resolutely kept her distance from young men; she no longer had any doubt, she was now sure that, against her will and in defiance of all common sense, she was the carrier of some evil spell. The kisses and exorcisory

dance had turned into overwhelming proof of it. And she dared not tell anyone this dark secret, for on the one hand she knew that no one would take her seriously, least of all those most directly affected, and on the other hand she sensed that if anyone were to believe her the consequences would be equally dramatic. She would then be accused, rightly or wrongly, of countless misdeeds.

So, with no less discretion than determination, she condemned herself to solitude. But though she might hold her youth and heart in captivity, she could not imprison her beauty. Despite her every effort to pass unnoticed, she escaped no one's gaze, least of all that of men.

Since she remained very distant, she was thought to have a high opinion of herself; some men interpreted this apparent coldness more cunningly; they saw it by way of a challenge, as an invitation to adopt an original strategy of seduction. And some tried, but no matter how keen and imaginative, every man that wooed her had to admit defeat.

Among these rejected suitors were three who turned out to be bad sportsmen, and indeed bad losers. What they were unable to win by charm they decided to take by force. They persecuted Sara with their attentions and made bold to steal a kiss from her, even trying to take further advantage. On each occasion Sara managed to escape, but the three daredevils paid with their lives for their transport of desire hours after they acted on it. Two killed themselves in a car accident, the third accidentally electrocuted himself at home.

As these three sudden deaths occurred in the same region within a few weeks of each other, and every one of the victims had bragged to his friends of his intention to deal a little roughly, very roughly, sensually speaking, with Ragouel's beautiful and too arrogant daughter, a rumour began to spring up, to gain ground, and soon to spread rapidly.

People spied on Sara, ransacked her life, her past, made up stories, and in the end imputed to her responsibility for every fatal accident that befell young men from the area.

Sara's parents, who until then had striven to set her mind at rest, to attribute to pure chance, to mishap, the tragedies in which she felt implicated, eventually began to wonder themselves. They said nothing to their daughter of their misgivings, and fiercely defended her whenever she was the target of scandalmongering and accusations, but they were overcome with great dismay. They were sure that Sara was innocent, indeed that she was beyond reproach, and moreover they were not at all the kind of people to allow themselves to succumb to superstition, they sought no fanciful explanation to this series of tragedies. Yet they could not but recognize that the series was turning into an avalanche and the coincidences were proving really too unreasonable, too perplexing, to be put down to mere chance. All the evidence suggested their daughter was afflicted with some calamitous power that escaped reason, escaped any attempt at explanation and justification.

Sara gave up the musical studies she had begun in Bordeaux and came back home to shut herself up in her parents' house. She did not go out any more, dared not even lean from her window, for fear of being seen. And within the walls of her bedroom, the living room, the kitchen, she paced round and round, till she brushed with madness in the prison of her fatal beauty.

Seven faces have appeared in the oval of the noose; their features are imprecise but they all have a youthful look, some even yet that of a child. And each of them has an expression of great surprise, as though still unable to understand the reason for having to quit life so early, so suddenly. They present themselves one after the other, a little haggard, and sad too;

they become just visible, momentarily, then fade from sight, returning to their limbo.

They said nothing during their fleeting appearance, did not even cast an accusatory glance at Sara; they contented themselves with merely a glimpse of the girl who was the unwitting means of their demise, their cruel young Fate. They said nothing, but the look in their eyes, of boys lost in an infinite fog, who had strayed into nowhere, unhappy boys, so unhappy not to be alive any more, thoroughly upset Sara. She then stood up, walked towards the rope whose noose was now only waiting to tighten round her neck, and thereby finally, and for ever, bring to a close the series of portraits of the dead. She did not want to be any more the ravishing Fate who in all innocence cut short the lives of young men crossing her path. But just as she was about to climb on the chair, two other faces flashed before her in the noose's gaping oval, the faces of her mother and father. Then she stepped back. She could only wish for death, for deliverance, only await them, but not take them by her own hand. She untied the rope, threw it on the floor and fled from her room.

Sara opens the door, circles the house, and flits to the steps cut into the cliff; she goes down to the beach. The sky is an ultramarine blue in which anthracite clouds go racing by. A warm and redolent wind is blowing. A slender crescent moon breaches the celestial heights. Sara goes and crouches on the seaweed-slimy rocks, her arms wrapped round her legs, her chin resting on her knees. She closes her eyes, deeply inhales the strong smell released by the low tide. She steeps herself in the smell of the estuary and its mingled waters, the smell of mud, of primordial matter; she welcomes into her flesh the bitter and tangy smell of this land-mouth opening to the ocean, this silt-lipped mouth blasted by history and human passions, thirsting for space, for the open sea, this mouth rimmed with vines, orchards, gardens, forests, that while cele-

brating the sustaining earth's splendour, goodness, prodigality, cries in silence to infinity, to that which is other and more than itself. Sara takes renewed heart from listening to this age-old mouth that smiles at the sea, enamoured of immensity. She unlocks her arms, stretches out on the seaweed.

She holds her breath the better to hear that of the evening and of the estuary. Her breathing slowly calms down, falls into rhythm with that of the elements. She half-opens her eyes; she sees the slender crescent moon hanging above, so high in the sky of ever deeper, intenser blue. A little horn of white incandescent light, but set on the forehead of what invisible animal? Or an eyelash dazzled by the plenitude of a thought, but fallen from what eyelid? Or an apostrophe marking the elision of every other sign – an all-embracing apostrophe stamped on the smooth stark sky, an invitation to silence, to indefinite waiting, to patience.

Sara closes her eyes again, her tears are contained. Her perception of sounds grows more and more acute: the lapping of water held in the hollows of rocks in which tiny creatures swim, the distant barking of dogs sniffing the darkness with suspicion, indistinct voices, the laughter of people passing overhead on top of the cliff, and the strange sound, reminiscent of drum-rolling, made by meagre rushing in shoals through the waters of the estuary.

Gradually the sounds become even more subtle, and send out unusual echoes. Distinct sounds of varied pitch and intensity come from the bushes and shrubs clinging to the cliff-face, the vegetal murmur fragments into a polyphonic melody. Every leaf has its own particular vibrato, but one that is in harmony with the rest and blends into the general melody. Sara listens to this multi-voiced humming that marries the utmost discretion with the keenest fervency, and she has an intuition that this delicate song resulting from countless quiverings is the work of a boundless and unguarded

patience, a beauty rapt in humility: every leaf, every twig, just like every drop of water in the ocean, its uniqueness, its singularity notwithstanding, does not tremble solely for its own sake, cannot be reduced to itself alone, but on the contrary is elated in its self-forgetfulness, quivers at the mercy of the wind, of the currents, rejoices in being a near-nothing. A very ephemeral near-nothing, moved for no apparent reason or necessity and gracefully rustling. Sara senses the mysterious fecundity of oblivion, of self-abnegation, she creates an emptiness within herself; having failed to commit suicide, she strives to become dead to herself, at least in some small way. Now she is no more than seaweed lying on the rocks, a fine black seaweed among piles of the stuff.

Another song, deeper, more sonorous, rises in the background. That of the waters of the Dordogne, and of the Garonne, swollen by all their tributaries descending from the mountains and meeting, commingling with the tides. From spring to rill, from brook to stream, from river to the sea, how many different watercourses have joined along the way, have given up their own song to become just one voice in a gigantic choir, a single thread in an ever vaster texture? It then seems obvious to Sara how much water, even more so than grasses and leaves, teaches humility, generosity, wondrous self-forgetfulness. Because from cloud to rock, from rock to estuary, from cave to the open sea, there are so many digressions, obstacles, meanderings, and so much self-surrender. What is left in the oozy estuary of the limpid, freezing-cold spring-water? What is left in the gaping estuary of all the landscapes passed through, all the towns and villages skirted, all the farm-land irrigated? An indistinct and yet pregnant memory, less than nothing but nonetheless the essential: the persistent force of momentum, the sheer desire to go elsewhere, ever on and on. What is left is the splendour of movement, of the continu-

ally renewed drive forward, and the passion in the singing, be it a babbling, burbling, or booming, high-pitched or low.

Sara listens to the intense song of forgetfulness that rises from the estuary, that indistinct clamour in which loss of identity glories in immolation, in which wandering finds resolution in dance and eddying swirl, in which water gathers, mingles, blends its voices that originate way back upstream, and releases an ever-expanding sigh. A sigh of surrender, of yielding to the boundless and the unknown. A sigh of deliverance.

Sara perceives the sounds not only through her sense of hearing, but through her entire body, through every pore of her skin, every heartbeat. She prays without even knowing it, or rather her body is in prayer, is a prayer. She prays through her responsiveness. And her mouth, whose kisses have always been seals of death, opens a fraction. There is no faint smile on her lips, just a breach in her terror. Without a word, without a cry, her mouth, which has acquired the taste of salt and seaweed, commits her lamentation and distress to the evening breeze. Her mouth is no more than a question cast into the void, a silent supplication addressed to the sky that has turned dark and is cut through at close regular intervals by the beam of the Cordouan lighthouse, standing on its faraway rocky islet. Her mouth is like that of the estuary, where a great work of escape, self-effacement and opening out is perpetually in progress. One breathes out a prayer of total destitution, of tremendous denudement, a whisp of breath in the night; the other gapes towards the open sea in a huge turbulence of waters heavy with sand, pebbles, fertile mud and desires. Flesh wound and earth wound alike are thresholds leading to infinity, yielding to adventure, to the unhoped-for. Both trusting in that immensity in which a sliver of moon shines.

THE COMPANION

Tobiah went to look for someone acquainted
with the roads who would travel with him to
Media . . . Tobiah said to him, 'Wait for me,
young man, till I go back and tell my father; for I
need you to make the journey with me. I will, of
course, pay you.' Raphael replied, 'Very well, I
will wait for you; but do not be long.'

The Book of Tobit 5: 4 and 7–8

A sliver of a moon shines over the marshes. The night is dark, immense.

Squatting in the heart of the marshes, flush with the sky, is a house. Every now and then shrill screeches punctuate the silence; the barn owl has taken flight, going after voles, sparrows and frogs.

A lighted window shines in the dark. Through the window two figures can be seen in profile: a couple seated opposite each other at a table, beneath the halo of a lampshade. Their movements have a slow, steady rhythm. They are eating, each bent slightly over his plate, raising a soup spoon or a piece of bread to his mouth. The lamplight gilds their foreheads, their hands. A dog of indeterminate breed, its thick-haired coat the colour of old ivory, is lying under the table. It is asleep, and occasionally sighs in its dog dream.

The diners raise their heads, wipe their lips with their napkins; they have finished their supper. They are not husband and wife, but father and son. One has very white hair, the other's is brown and curly. Their eyes are polished by the silken light of the marshland skies, by the clouds and mists, their mouths are fed on wind, bird-cries, and silence. Especially silence.

They rarely exchange words, not that they have nothing to say to each other, but they do not feel the need to express every passing thought, every passing emotion. More often than not, they express themselves with a nod of the head, a mere gesture, a glance, a smile. The son has grown up in the shadow of a father who was for a long time half-dead, almost mute, fantastically absent in his violent immobility. He has grown up too in the light of a great-grandmother who sang in an ever deeper, purer voice the remembrance of her dead, the

107

unfailing expectation of coming face to face with God. The words, the son found in books, stole them, mastered them. And they were far more than words of ink on sheets of paper: they were algae swaying in fire and water, bronze whips, sputum and phlegm with the iridescence of quartz crystals, glints of flintstone wrested from the earth, fragments of stars buried in the bluish clay, dust originating from distant expanses with the splendid names of desert, steppe, pampas and Milky Way, and also flying up from the streets and backyards of seedy suburbs. Words of raw matter that the child sounded next to his ear, next to his heart, then threw from the tree-tops for the wind to carry, to send spinning round like the whetted blades of a windmill in the deafening silence separating him from the dead, so as to rend that silence.

A lighted window shines in the dark. The barn owl skims over the tiled roof, dives down into the bushes, screeching. The dog under the kitchen table lifts its head, gives a slight growl, then buries his muzzle between his paws again. The father sweeps up the crumbs strewing the table, throws them in his plate, on which a bright-red apple-peel spirals round the blade of his knife. Tobias drains his glass and is about to get up, but Theodore asks him to remain seated for a moment. He has something to say to him. He begins by reminding him how poor they have become because of his chronic debilitation, but he stresses that this poverty should not cause them too much anxiety, they should just take account of it and act accordingly. Then he tells Tobias that he once lent a large sum of money to a friend now living in Bordeaux; because of his illness he has long neglected his affairs as well as his friendships, but he believes the time has come to restore a little order to his life, and that is why he wants Tobias to go and collect this money. At first Tobias declares himself incapable of carrying out such a task, Theodore reassures him, tells him about the man whom he knows to be honest; and he has prepared a

letter and all the necessary documents for this forthcoming visit.

If Theodore has finally decided to send his son to collect this debt, it is because his financial circumstances are indeed extremely reduced, and above all because he feels that life is slipping away, that his days are numbered, and he is worried about Tobias's future. He wants to provide him with some money and also with a little boldness by forcing him out of the network of streams, ditches, creeks and canals where he was born and has always lived, to wrest him for a while from these arms of languid, grassy water, which have cradled him since childhood, these silted arms of such soft and sparkling green. Tobias feels at home with willows, ash trees, poplars and elms, he is familiar with the entire fauna of the waters, thickets, reedbeds and woods, he is intimate with the wind, able to distinguish its inflections and variations in smell according to the hour of the day and the mood of the season. But he must also learn to read men's faces, so often masked, and their hearts, so often devious; he must go into the towns, wander through their streets, inhale city smells and no longer delight himself only with the peppery fragrance of horsemint, the sweetishness of vernal grass, the bitterness of angelica . . .

'It would be a good idea to find a companion for this journey,' Theodore suggests.

'In the time it takes me to find one, your friend is very likely to die and your money to completely moulder,' replies Tobias, who has no friends, just good relations with the local people.

'Someone's bound to cross your path . . .' says Theodore.

And they fall silent again, nothing more needing to be said. Tobias stands up and clears the table. The dog shakes itself and starts ferreting round the kitchen, then goes and stands at the door, waiting for it to be opened. It is time for him to take a final turn outside.

A tremendous racket reigns in the wood; there are cracks and creaks, grotesque gurgling noises, cries deep and shrill, rustlings, squealings, and even a kind of idiot laughter. Yet there is no one about, only Tobias who is stepping very carefully over the mossy ground with very bright-blue flowers peeking through among the shrubs and ferns. But the noise does not come from the ground, it is being created higher up. All the trees are crowned with nests made of twigs and reed stalks, and a frantic ballet is taking place overhead. The herons come and go, carrying in their beaks frogs, molluscs, eels, insects that they continuously bring to their insatiable young. A black kite, which has settled in the heronry at the top of one of the tallest trees, is on the lookout, awaiting the auspicious moment when a nest will be left unprotected, the two parent birds gone in search of food, then it will swoop down on the squalling brood, carry off one of those balls of warm and fluffy flesh to feed to its own greedy tribe. But the female herons keep watch, necks outstretched, a very round and yellow eye intently gazing into space, ready to defend their offspring with their dagger-sharp beaks. So, for want of anything better, the black kite dives towards the ground, seizes upon some fish remains, fragments of eel or snake regurgitated by the heron chicks, or a little runt tossed out of the nest by its mother. To each its beakfull, which is a hard-won trophy that has to be fought for. In the heronry every chick is on the alert, in a frenzy of hunger, curiosity, hankering. Each fights fiercely, ferociously, for its belly and its life.

Tobias remains in the undergrowth for a long time, observing the wader-birds' aerial ballet, and the black kite's art of watching. The beauty of all these birds in flight carries the price of this voracity, this cruelty. And it is the same with insects, with water creatures. It is the same everywhere in nature, even in the sky, where the stars shine all the more brightly when they are dying. And how is it with humans? Tobias wonders, as he leaves the grove where the din con-

tinues. He senses that for beauty to be born and develop, it needs to undergo desperate struggles, ravages, convulsions, and many self-denials. The splendour of the marshes in winter, when the rivers flood, when the fenlands are veiled with water, the trees laced with frost and mist in which the sky's silver paleness is mirrored, its bareness accentuated: what is this, if not a white violence done to earth, grass, bark? And the sumptuousness of flames flaring up in a crackling of carmine-red splattered with golden pollen and shadow, streaming in an upward-falling cascade, a living spring flowing backwards: what is this, if not a laceration, a devouring of matter?

Each of the elements harbours chasms, surges, tumults of beauty, and this fifth insubstantial element that is language contains the most lofty promises, the most insane feats of beauty, an agonizing beauty. Tobias has felt the great breath of language brush his heart, make him reel, or at least teeter on the brink of a sheer drop, between ecstasy and disaster. A few lines of a poem, a sentence of prose are sometimes all that is needed to arrest time, to isolate a moment from the continual flux and hold it in suspense, a sun-pause spreading, through the dark partition of time, a silence, all of tremors, tinklings and dawn undulations.

But a visual poem suddenly appears before Tobias and introduces an unexpected note into the day's score. A dazzling white egret dances a slow dance on the edge of a mere. It is not engaged in any amorous display, there is no reason for its dance, improvised out of pure pleasure. It turns with slow grace, bowing and swaying its neck, lifting its tapering-feathered wings, like foam-tipped waves.

Although alone, it dances like this not for itself but for the translucid light that emanates from the sky and water, for the wind and open space. This the nomad returning from South Africa. Returning from somewhere yet more distant, and very close by; Tobias remembers the egret that took flight from the

banks of the Mignon, nearly ten years ago, the afternoon that Deborah threw a pebble into water a few days before she died. And the old woman's face furrowed with luminous wrinkles suddenly rises in his memory like a moon between the clouds. It is from a glade of his childhood that the white egret is returning, and its dance is a reminder of Deborah's smile. And a forgotten name, a name she spoke of on the evening of her last sabbath, resurfaces in Tobias's mind: Medjele. 'May God liken you to Medjele,' Deborah had said, laying her hands on his brow. But he still does not know who Medjele is.

He observes the bird from a distance, so as not to scare it, but he notices someone sitting very close to the animal and is surprised by this; egrets are not in the habit of lingering near humans. Emboldened by the presence of this person, he walks, light-footed, towards the mere. The bird turns one last time, then rises from the ground and its circling turns into flight. Tobias stops, watches the egret skimming over the reeds and soon disappear. He feels regret, although he is not surprised; beauty always comes by unexpectedly, like a flash of lightning, then is gone. Beauty is erratic, unpredictable, untamed, like its messengers the birds.

He is already turning and about to leave, he does not want to disturb this rambler sitting by the pool. But the other person begins to sing brightly. Tobias turns round again, the stranger waves to him. Tobias hesitates, and finally goes towards him. Anyone who does not frighten away an egret is not someone to be mistrusted, he says to himself.

Is it a young man, or a young woman, Tobias wonders as he reaches the water's edge. This person has middling-long hair, of light chestnut with glints of gold, tied back in a pony tail, and is wearing a white linen shirt, without a collar, and a pair of faded grey jeans. The barefoot stranger's toes play with the grass.

'Hello!' they both call out at the same time.

'This pool gets a lot of visitors,' says the other, whose voice is both soft and husky. 'There are buntings' nests here, I've seen an adder passing by, frogs jumping, dragonflies flitting about, bees foraging, an egret dancing, and now you're here.'

'My name's Tobias,' he says abruptly, in an almost curt tone, as if he wanted to distinguish himself from the creatures and insects the other had listed.

'And I'm Raphael.' And having given his name, he stretches himself, then lies back on the grass resting on his elbows.

Tobias notices that he is not wearing a watch on his wrist.

'Do you want a marvel?' asks Raphael, half-reclining.

'A marvel?' repeats Tobias, a little flummoxed by this strange proposal.

'Yes, they're delicious in this part of the world,' says the other, turning to a knapsack lying beside him from which he extracts a paper bag full of beignets, consisting of a thin fritter of scallop-edged pastry dusted with sugar. Tobias takes one and tastes it.

'It's a very pretty name for a pastry,' says Raphael, biting into one too.

Tobias sits down beside him, they both nibble their beignets and observe the landscape for a while in silence.

'Where do you come from?' Tobias eventually asks.

'Oh, here and there, I go with the wind, like birds and pollen.'

'Birds always have a place of origin and a destination,' Tobias remarks.

'My place of origin is both very remote and very near-by, my destination varies, depending on my infatuations with the colour of the sky, and depending on the encounters I have on the way. But wherever I go, I never stray far from my place of origin.'

'That's not very precise in geographical terms! It sounds like a riddle,' says Tobias.

'Don't judge by appearances, I'm an extremely precise kind of person. I always know what I want, I passionately want what I know.'

Tobias is left perplexed. He has never asked himself what he truly wanted. Certainly, a great desire has burgeoned within him, but this desire remains still vague, it is an un-formed impulse, without definite focus, an irresolute force, a smouldering fire. And he suddenly feels a slight bitterness towards himself, he considers himself extremely faint-hearted. Raphael shakes him out of his gloominess by continuing the conversation.

'I'm off again tomorrow, I fancy paying a visit to La Rochelle. You must know the town well, I imagine . . .'

'Not very well, no . . .' confesses Tobias, who has not been back there since that school trip long ago. Actually he has almost no memory of the town itself, which he thinks of as a bestiary of sundry species: a phantom whale, fish of all shapes veering this way and that behind the glass walls of the aquar-ium, a giraffe wearing a shadow crown, bird skeletons, deer antlers, a suspended crocodile, and above all tattooed and grimacing human heads and skulls, and the two-headed statue. Tobias sees this weird procession of silent animals and detached heads flash past him; only the statue makes a brief stop, gleams and fleetingly hails him from the depths of semi-oblivion in which it slumbers. 'Moai kavakava . . .' he mur-murs, with an emotional smile as if running into a long-lost friend, but he immediately recovers himself and adds, 'In fact I hardly know it at all.'

'You wouldn't like to go and spend a little time there?' Raphael then suggests.

Taken aback, Tobias stammers, 'But . . . I have to go to Bordeaux . . .', suddenly remembering the mission his father has given him, and which he is reluctant to accomplish.

'Perfect,' the other says casually, 'come with me, we'll go from one town to the other following the coastline.'

Tobias looks at him with some surprise and replies, 'It's not really the shortest route . . .'

'So what? The shortest routes are rarely the best, they're often far less interesting than the longer way round. Beware of straight lines, they're dull and eventually send you to sleep. Anyway, it's a matter of taste. I prefer the indirect path, the unlooked-for, the out-of-the-way.'

Tobias feels he has very little time for hesitation, for reflection, and suppressing a wave of panic he says in a rush, 'All right, let's travel together.'

Whereupon Raphael leaps to his feet, picks up his knapsack, which he throws over his shoulder, and says, 'We'll be off then?'

Once again Tobias is disconcerted, this is going a little too quickly for him. 'Wait,' he says, 'I need to go back home before we set off. I have to let my father know and pick up a few things. Come along, I'll introduce you to my father.'

'With pleasure, and since we're going to be travelling together, let's not stand on ceremony with each other.'

Tobias nods in agreement.

As soon as they enter the yard the dog comes bounding towards them, yapping. It jumps up at Tobias and licks his hands, then turns to Raphael and greets him likewise.

'Usually, he's rather wary of people he doesn't know, he even growls at them,' Tobias says with amazement.

'Dogs are always pleased to see me, unlike people who can sometimes be hostile.'

They go into the house. The muted strains of haunting melancholy music filter through the drawing room door; a bell rings at intervals against the playing of stringed instruments, but suddenly another sound mingles with this slow musical reverie. It is the clock, its metallic chimes striking eleven. Tobias opens the door into the drawing room. Theodore is sitting in an armchair with a book lying on his lap. He is

dozing, his head tilted to one side. The light flooding into the room is powdery, straw-coloured. The music pursues an insistent phrase that quivers, intensifies, then dies away to the discreet ring of a bell. The radio is broadcasting a work by Arvo Pärt: 'Cantus in Memoriam Benjamin Britten'. Tobias walks softly over to the armchair, places a hand on his father's shoulder, brushes his face with a kiss. Raphael waits at the threshold, the dog at his side, rubbing against him. The radio continues to broadcast works by Arvo Pärt. 'Festina Lente' is now diffusing in waves, sometimes crystalline, sometimes tenebrous, a music that draws a fine line round silence, that tinkles between darkness and light, that dwells upon itself, ever gaining in purity.

Theodore opens his eyes, his gaze remains bleary with dreaminess for a few moments, then he smiles at Tobias. 'Ah, it's you . . .' he says; there is a great weariness in his voice.

'Yes, I'd like you to meet someone, a friend. We're going to make the trip to Bordeaux together, just as you wanted. His name is Raphael.'

At the mention of his name, Raphael steps forward to greet the old man. His handshake is so warm that Theodore feels a very gentle unsettling, like a ripple of fresh water and light through his aching body, and his immediate thought is that Tobias has found himself an excellent companion.

The three of them chat for a while, then have lunch together, and after the meal Theodore hands his son the letter and papers he has prepared, reiterates some advice, and finally accompanies Tobias and Raphael out to the road. The dog bounds along at their heels, wagging its tail.

'Let him come too,' says Raphael, 'dogs never ask any questions, they sense everything, and they decide without hesitation between what is good and what is bad, which is why their company is no burden.' And all three set off on their way.

The great frenzy that overcame Valentine on learning of Anna's death gradually relapsed, she no longer went running in all directions, babbling like a restless infant, she stopped smearing with lipstick reflections of her face in mirrors, she quite simply remained silent. Morbidly so. She had lost all desire to speak; words no longer rustled inside her, the clouds, wind, trees, seasons and sky no longer made her dream. Arthur had won, he had destroyed the spirit of childhood in her, her patience was now no more than exhausting boredom, the world had lost its magic, and she was wilting away.

She never left the house any more, she spent her days confined to the kitchen, collapsed on a chair. She led the life of a penitent, as if she had to expiate a crime for which she could not forgive herself. The crime of still being alive, perhaps, when Anna was dead, in the prime of her youth and beauty; Anna, to whom she, having remained childless, had transferred all her frustrated maternal love.

Old Deborah had come to visit her, had tried to reconcile her with life, and a few neighbours too had called on her, but to no avail, Valentine remained beyond reach, no one succeeded in rousing her attention, not even in holding her gaze. The suggestion was made that she should be taken to hospital, but Arthur opposed this, and furthermore to put an end to any further visits he locked his wife in the house every time he went out.

But then all of a sudden, on this sunny afternoon when Tobias has just set off with his dog and Raphael for company, Valentine lifts her head, rises from her chair and gives a long sigh as if she was emerging from a heavy sluggish sleep; she shakes off her torpor, goes up to her room, changes her clothes, tidies her hair. Then she comes back down to the kitchen, opens the cupboards, finding them quite bare and her kitchen utensils filthy. She washes a pan, a dish, and sets out on the table a packet of wheat-flour, some caster sugar, salt, two eggs, butter and a jug of milk. She goes on hunting, looking

for two essential ingredients for the cake she has decided to make: almonds and ground cinnamon. In the end she finds some in a tin decorated with branches of holly. She softens the butter, then dissolves the sugar in it, adds the eggs, flour, almonds and cinnamon. She kneads the dough until it is quite smooth, sprinkles it with flour, then covers it with a cloth and leaves it to rest. And she waits, singing softly to herself.

She rolls out the pastry, spreads it in a flan dish, pours over a mixture of milk, sugar and cinnamon, and slides the dish into the oven. Again she waits, as in the past, when she used to prepare pastries and delicacies from recipes passed down to her from her mother and Deborah. As in the past, when she looked forward to Anna's arrival with little Tobias.

She takes the cake from the oven, turns it out, but does not leave it time to cool. She wraps it in paper, then in a linen cloth, and puts it in a shawl. She cleans the kitchen, tidies everything away, takes the shawl containing the cake and ties the corners together, then slips it round her neck; the shawl hangs across her breast like a slim pouch. She goes to the door, but it is locked from the outside, so she leaves by climbing out of a window, closing the shutters behind her. And off she goes.

The daylight blinds her, at first she almost gropes her way forward, and she staggers a little in the warm breeze, with its rediscovered smells. She glides rather than walks, the grass caresses her heels, she smiles, a weak but peaceful smile, and she starts singing to herself again.

Slowly she grows accustomed to the daylight, to being in the open; she notices that at her every footstep clouds of little butterflies take wing, yellow or white flecks that flit upon the greenness while very delicate, deep-blue dragonflies steer their way among the grasses, veering at sudden right angles.

Calm is the day that extends over this land, calm and radiant. Valentine is released from her long night, from her fear. She is already old, and in poor health after so many years of

confinement, but she does not feel the weight of her years in the least; life, which she for so long kept subdued, reduced even to the extreme, resurfaces in tiny waves. She has no baggage, no money in her pocket, and no idea where she is going. She does not care, it is enough that she is going. She is now reborn, at her time of life, a mayfly-woman who has remained in the larval state for thousands of days and whose moment of hatching has finally come. It little matters to her to know how long this new life will last. To her, it feels eternal.

Valentine walks along the road in the opposite direction to that taken by Tobias, but she too is making for the open, she is venturing into the uplands. She feels neither hunger, nor thirst, nor tiredness, nothing but the joy of being summoned outside and beyond herself in this way, liberated from penitence and terror. And besides she is carrying this still very warm, soft and fragrant cake; it is for Anna, for her mother, for Violette and Deborah that she has made it, for all the women in her family. It is a cake of welcome, welcome to those women who are no longer, who have entered upon the mystery of death but who today have brought themselves to mind again, have invited her to rise from her chair, to rediscover the ancestral motions of cookery, of the offering of food. It is a cake of gratitude, and she is on her way to share it with the four women she has loved, the unseen who accompany her.

Vast is the evening that settles over this land, vast and deep. Valentine has a rendezvous with the mystery of her heart, with the springs of her memory.

Arthur comes home at nightfall. He sees the chair on which Valentine was wasting away with tedium and sadness. The chair is empty, but also the kitchen, the whole house, and both the yard and the shed are empty. He searches every nook and cranny, he bellows Valentine's name, he swears and spits with anger; he does not find her. He returns to the kitchen where a

vague smell of baking still lingers, but there is no cake, nothing. He does not understand, or rather he senses that Valentine has gone never to return. So he begins to pace round the chair and shout, he waves his fist, he makes threats.

He leaves the house, goes and locks himself in the furnace building. He has a stash of bottles there. He opens one and drinks straight from the neck; he smashes the bottle against the oven door, opens a second, which he drains in a single draught, then a third; he clambers up on to his high chair. He throws himself about so much that his seat tips over and he falls to the ground; he remains lying in the dust, among the broken glass, and he sinks into a drunken sleep.

He sleeps until the early hours of the night. When he wakes he hears a great cacophony inside his head. His head is full of broken glass, broken cries, burning embers. He returns to the house, the chair is still empty. Then he goes upstairs, rummages in Valentine's wardrobe, but does not find what he is looking for; he goes into the boxroom, opens the chests stacked there. At last he finds the garment he needs. It is Valentine's wedding dress, folded away in a trunk for more than half a century. The fabric has so yellowed, so aged, that it looks as if it is made of straw, and the moths have been busy making lace of it. Arthur removes the nuptial tatters, uses them to dress the chair that is driving him mad by remaining so obstinately empty; to fill out the dress he stuffs it with cushions and rags, and he slides a pole down the back which he wedges between the bars in the backrest. The dress is now sitting properly in the chair, ramrod straight; he sticks the feather duster into the neck.

He takes the chair in his arms and carries it to the edge of the river, to where his boat is moored. He props the chair at the front of the boat, then returns to the house; he goes into the shed, loads some oil drums onto a wheelbarrow and takes them to the boat. He unties the rope, settles aboard, seizes the oars.

The cacophony is getting louder inside his skull as if the din of the countless bottles he has smashed night after night against the mouth of the oven is concentrated in his head. He rows, grinding his teeth with the pain of his relentless head-ache. The bride sits enthroned in the prow, the folds of her gown swishing the surface of the water, its idling current slug-gish beneath the soft green velvet of the duckweed.

The boat glides through the winding canals. Arthur has set down the oars; he picks up the oil drums one by one and slowly empties the contents onto the water. Then he takes a box of matches from his pocket, and says to the figurehead at the prow: 'You see, Tine, we're finally going on that honey-moon!' Whereupon he strikes the matches and throws them overboard. The little posy of flames immediately blossoms, turns into bouquets, then unfurls in a long garland.

The river is in flower, ablaze with flowers. A great commo-tion breaks out in the water and on the banks; otters, coypus, vipers, birds nesting in the roots of pollard ash trees, among clumps of sedge, come bursting out of the flames. A duck takes flight with strident cries, its plumage on fire. 'Hey, look, Tine! There's a mallard thinks he's a rooster, a right royal rooster! He's got flaming cock's-combs to the very tips of his wings and claws!'

The fire scuttles across the duckweed, licks at roots, entwines reeds, makes nests crackle. Pink gleams shimmer in the bride's gown, dance in Arthur's eyes, waver in the dark.

'I told you we could get the old oven alight! Ah, there was plenty of fire in the old stove yet!' And he laughs, and his laugh is as grating as the cries of the mallard which in its frantic flight catches the bride's feather duster with its wing, then plummets into the water. The duster quivers, the bride's head is all ruffled and starts to turn red.

'Sing, sing, my little Tine! You're so pretty when you sing . . .'

Arthur moves up to his figurehead, bends over the chair, takes the stuffed dress in his arms and holds it close.

'And now Tine, we're going to dance! Sing, sing for me . . .'

The fire sings softly in the bride's hair, Arthur sways, clasping the dress. His hands, soaked in petrol, catch fire, and the fire spreads across the bride's back, sweeps into the folds of her dress. Arthur clasps her even more tightly to his body, their clothes become covered with blisters that burst with a whistle of 'Sing, Tine, sing for me . . .' Their two bodies become one, streaming bright yellow and scarlet, they stagger, then collapse into the bottom of the boat, and it too turns into a torch.

A long beacon glides along with the water's flow, mingling its roar with the cries and clamourings of the aquatic creatures that have taken refuge on the banks; the twisted, dishevelled silhouettes of the pollard ash trees stand out against this orange-coloured chiaroscuro, like a procession of gnomes and wizards at some great conclave in the night.

And as the beacon dies out at the clawed and bushy feet of the marsh gnomes, Valentine, who had fallen asleep in a meadow under an oak tree, wakes up. The night is peaceful, and Valentine is imbued with this peace; she has slept on the ground, in the coolness of the grass and the rustling of foliage. She has slept close to her heart, in the sweetness of consolation and the murmuring of her memory. She wakes, sits up, and smiles, alone in the silken silence of the night. Alone and yet in company: four women are seated round her, as light as the breeze.

She is hungry. She opens out the shawl, then the cloth the cake is wrapped in, and removes the paper. Since she has no knife, she breaks the cake like a loaf of bread into five equal portions. She distributes these portions, one to each of her transparent companions, one for herself. She slowly savours the first mouthful, the taste of cinnamon mingles deliciously

with that of the sugar and toasted almonds and as she does so a deep gratitude grows within her; gratitude for life, for the sustaining earth, gratitude for death which she now perceives as a wondrous mystery, and for the four transparent beings who have come to join her. But as she raises the last mouthful to her lips she hears a voice whispering in the night, in the rustling foliage, in the resonant throbbing of her heart. 'Sing, Tine, sing for me . . .' And she gets to her feet, and starts to sing; the taste of sugar, cinnamon and almonds blends with her song, gives her voice a warmth of sound, colours it brown and orange-gold. And the pure silence of the four transparent beings encircles her song, enhances it with echoes. 'Sing, Tine, sing for me . . .' It is for all the women that Valentine sings, for Rosa and Violette, for Anna and Deborah, and for Arthur too, who in his turn is gone. For Valentine feels in her mouth a breath other than her own, a failing, burning breath, one that rises from her heart, one that creeps in her blood; it is a lament, an appeal, a confession, it is a begging for forgiveness. A farewell.

Valentine lays the shawl over her shoulders, she crosses the meadow and, still singing, sets off on her way back home. Her flight will have lasted only a few hours, but the duration of her upland odyssey cannot be calculated, it does not fall within time measured by clocks.

The night exudes a smell of damp grass, of sugar and cinnamon; there is also a smell of burning. Valentine walks with a relaxed gait, sings under her breath, her forehead held high. It is not tiredness she feels, but an absolute inward nakedness, a levelling of her entire being. Everything is consumed: unhappiness, sorrow, fear. Everything is forgiven: the wickedness suffered, the love rejected, the loneliness confined by anger. Everything is consoled: the grief and distress. She has kneaded and baked the cake of reconciliation and has shared it with the guests of her memory. She has eaten the cake of the dead, she

has rediscovered the savour of life and of the earth, patience and clearness of vision, the desire to endure, to grow old in this world, and the secret of singing to establish fugitive dialogues with the spirits of place, of the living and the dead.

THE FISH

Now when the boy went down to wash his feet in the river, a large fish suddenly leaped out of the water and tried to swallow his foot. He shouted in alarm. But the angel said to him, 'Take hold of the fish and don't let it get away!'

The Book of Tobit 6: 3–4

Having covered some ten kilometres, they stop in a village and go into a bar. Some men are engaged in an interminable discussion at the counter. They are commenting on the day's news: insignificant news that they do their best to raise to the level of epic, tragedy, or melodrama, depending on the event and how they feel about it. One of them recognizes Tobias; they are from the same village. From the stool on which he is perched, the man greets him and starts a conversation. Learning that Tobias is going to La Rochelle, he offers to drive him to the coast, a little north of the town.

'I'm going to Lauzières, I've room in my van for you, your friend and your pooch; it'll get you closer to where you're going.'

Tobias accepts and the other, staring at him across the room, suddenly cries out, 'It's amazing how much you look like your mother, the lost head!'

Immediately realizing his tactlessness, and indeed the bad taste of his remark, he coughs with embarrassment. Tobias keeps his head down at the table where he has just taken a seat. To break the silence the barkeeper remarks casually from behind the counter, 'She sure was a good-looking woman, I still remember her well . . .'

'And that great-grandmother of yours,' exclaims the blunderer, trying to change the subject, 'what a damn fine lady she was! A tiny little thing who kept going for a hundred years, working hard all her life, as fit as a fiddle, and what an accent! And she never got in anybody's way!'

Tobias smiles at this portrait of Deborah, painted with a trowel, but he thinks: 'She lighted the way. Without her I'd have been lost.'

Tobias and Raphael arrive in Lauzières in the late afternoon.

'Let's go and look at the sea,' says Tobias.

But the tide is out, a few fishing boats in the harbour are stranded in the mud, of a light-bronze colour, among some large red and orange buoys. And Tobias thinks of Deborah's grave, just after the tears that her body shed from beneath the earth had subsided. The miniature fleet he had constructed lay just like that, every boat tipped on its side. He left it there, as an offering, along with his childhood. And his dreams of adventure – of sailing to Easter Island – seeped away in the grass, in the rain. But just as the dead blend into the soil, the sap, and fertilize plants, flowers, and roots, are not the ardent dreams of childhood likewise relinquished so that they can turn into drizzle, into pollen floating in the wind, twinkling through time with fleeting and discreet brilliance?

Driftwood, bits of scrap metal and rope, eaten away by the salt and the water, strew the iridescent mud with its gleamings of brown, rosy beige, lilac and pale gold. The mud looks so greasy, so oily, constantly caressed by the water, the wind, the light, the shadows of seagulls and terns wheeling round in the harbour, and these caresses make it shimmer with furtive ripples as if it were the skin of a body surrendered to voluptuous idleness. Strands of seaweed of a green that is almost black drape the rusted cables and bollards.

'And now we're going to start looking for our supper!' says Raphael, rolling his trousers halfway up his calves, and he sets off along the seashore. He is barefoot.

'I never wear shoes, so as to keep closer to the ground and to feel the earth breathing,' he has told Tobias, who was amazed to see him walking like that, whether across meadows or on the road.

He picks his way nimbly over the broken seashell-encrusted rocks along the shore, paddles with delight in the pools of water, and collects oysters and shellfish. The dog runs

about in all directions, yaps at birds, shakes itself vigorously, then gets wet again.

'I think we have enough,' declares Raphael after a while, considering what they have gathered.

They sit on a rock facing the sea that is still receding. Not far from them some oyster farmers are busy round some long metal tables on which they are turning out heavy net sacks full of young oysters.

'What skill and patience those people have,' says Tobias, watching them, 'we're just poachers.'

'No, gleaners, rather,' Raphael corrects him, 'and gleaning too is a skill, like the way Ruth gathers up after the reapers in Boaz's fields of barley and wheat. She only collects the ears of corn that are fallen on the ground, and overlooked – the crumbs, the leftovers, and she lives on that.'

'Like the birds, then?'

'In a way, yes. And now here we are, transformed into oyster-catchers . . .' Whereupon he draws a knife out of his pocket, and a big round loaf and a lemon from his knapsack.

'Your bag seems like an Aladdin's lamp,' says Tobias, 'it's not very big and yet you're always bringing something wonderful out of it!'

'Oh, just a little food, no treasure; but it's true that food is a wonderful thing when you're hungry, especially in its simplest forms. Fruit, plants, sap, juice, seeds . . . Lao Tzu apparently survived on sesame seeds. Here, taste that . . . ' And he hands Tobias an oyster that he has just opened and sprinkled with a few drops of lemon juice. But Tobias shows a little aversion to the mollusc. Raphael gives him a slice of bread and adds, 'Go on, eat it, you'll bite into a morsel of ocean, it's rare to have the opportunity to savour the elements, to taste their subtle flesh.'

The dog settles for some bread that he gobbles up, for want of anything better.

It is sunset, but the sky turns neither pink nor red; the blue

of the horizon deepens, the light becomes even more diaphanous and the clouds milky, the pools of water along the strand take on tints of purple, mauve, and jade. Every colour is saturated, glowing with intensity. A flight of terns passes in the sky with the gracefulness and dazzling whiteness of a rising wave whose crest is already curling and breaking. Tobias and Raphael watch until they disappear, then they get up, leave the harbour, and walk through the village with its low houses flanked by sheds, tanks, hoop nets, lobster pots, and boats.

They take a narrow path that runs along the edge of the cliff. Walkways built on the foreshore lead to little wooden cabins suspended in space; large square nets hang gaping from the end of them. These huts on stilts are suggestive of rare and delicate birds, they have the legs of waders, the body of fat grouse, a pelican's beak and an inordinately long pheasant's tail, but no wings.

The path is covered with fine white gravel. It seems to lead nowhere, to be a path purely for aimless wandering, daydreaming, patient waiting. Silhouetted in the distance are the giant cranes in the port of La Pallice, and the arc of the bridge to the Ile de Re.

In silence they follow this white path winding along the edge of the ocean, flush with the sky, the light – this narrow highway into nothingness. The sun has gone down, the sky displays the entire gamut of blue, from the very palest to the very darkest, the sea is receding ever further, and a corresponding sense of emptiness grows within Tobias. Inside him too a great ebbing is taking place, time is slipping back, draining away, the present is unravelling, becoming riddled with gleaming holes like fragments of mirror, opening out like the shore that extends vastly to his right beneath an even vaster sky, of a blue so deep it is blinding.

And now his shadow, cast long and thin on the white path, detaches itself from him and begins to quiver, almost imperceptibly, like the hand of a clock jumping out of its axis and

loosening the moorings of time. His shadow creeps over the ground, it contracts, and makes movements independent of the walking body. And at the top of it the features of a face emerge; it is Tobias's face when he was a little boy.

The shadow-child fixes his gaze on Tobias. It is an anxious, sorrowful gaze. A gaze wounded by the placid violence of the visible world from which familiar beloved faces have been brutally expelled forever, as if those faces had been nothing but vapour, or even mirages. But those eyes remember, they retain on their retina images of the living whom death has abducted, and desperately compare their haunting interior visions with the deserted emptiness of this world, the forgetful visible world, implacable in its indifference. And his scouring of the visible world's smooth, denuded exterior, his scanning of the horizon, his peering into the light as well as the dark make his eyes burn, consume them. Bereavement and unhappiness bring insomnia even into the middle of the day, which is radiant now only with absence and loss.

The shadow-child stares straight into Tobias's eyes, and he feels that his childhood has been left unconsoled. It asks for nothing, makes no claim on the young man he has become, no, it simply appears before him. It appears like a witness bereft of a voice, bereft of everything except the dread it carries within it, in its flesh, conscience, heart, memory; the dread of what it has seen, and never ceases to see: the elimination of a living person from the visible world. It appears in the starkness of its affliction, in the powerlessness of its rebellion, in the insanity of its expectation.

Mother, I'm no good at looking for the dead
I get lost in my soul, with its steep faces,
Its brambles, its watching eyes . . .

Help me return
From horizons I'm sucked towards by vertiginous brinks,

Help me to be still,
So many gestures separate us, so many cruel hounds!
Let me lean over the spring where your silence takes shape
In a reflection of foliage your soul causes to quiver . . .

The shadow-child quivers on the path, marking time that does not pass, time that has stood still since the moment of an irreversible, irremediable loss, the frozen time of grief. Slowly the image fades, becomes a shadow without face or eyes, an indeterminate shape moving in accord with the body that projects it. But Tobias feels a weight fall upon his heart, stoop his shoulders, he raises a hand to his temple, his head is swimming a little. A question suddenly overwhelms him: is he then so like his mother physically, and so like his father in character and disposition? Did he come into the world only to be initiated at an early age in unhappiness, and loneliness, and to be dedicated to them for the rest of his life? Was his only fate to be that of a son left motherless, mutilated in his motherlessness, a son full of pity for his devastated father? Was his only fate to be that of man bruised and weary before his time?

Raphael lays a hand on his shoulder. 'Are you all right, Tobias? Are you not feeling well?'

'It's nothing, just a little dizziness.'

'We're going to stop for the night, you need to rest.'

'I don't see any shelter in this open country.'

'Perhaps not on the cliff,' replies Raphael, 'but suspended between earth, sea and sky, there is!' And Raphael makes for a very rickety walkway constructed a little beyond those they passed a short time ago.

'Where are you going?' exclaims Tobias, 'those walkways are private, and their gates are locked. And what's more, this one looks derelict and on the point of collapse!'

'If it's derelict,' retorts Raphael, 'then it's no longer private, and we can use it. Are we not gleaners? Well, then, let's glean some shelter for the night! Anyway, it's not as shaky as you

are . . . ' And he sets off along the walkway, having given the gate a gentle shove with his shoulder.

Tobias follows him. They reach the deck.

'The wind's blowing even stronger here!' says Tobias.

'Excellent,' says Raphael, 'it'll perk you up.' And he forces open the door of the cabin.

The wind whistles over the corrugated metal roof, which is in want of repair in several places. Some wall slates have fallen out. There is a small table, a stool, some upturned buckets in a corner, a few empty bottles, some old torn nets lying on the floor, and a wooden bunk. Rust and damp have long ago taken hold on these premises.

'Could you wish for a nicer room?' asks Raphael, setting his knapsack on the table. 'A balcony at sea!'

'Right now it's more of a balcony on the mud . . . ' Tobias corrects him, breathing in the strong smell of seaweed that fills the hut, which is open to the four winds, to the rains and mists.

'You sleep in the bunk,' says Raphael, 'I'll sleep on the floor, I'm used to sleeping on the ground.' He spreads out the nets, folds them into a long rectangle, prods his improvised mattress with his toes and declares himself satisfied.

'But all the same, you're no fakir!' says Tobias with concern.

'My rope bed would make any fakir laugh. It'll be just fine, I'm thick-skinned – a leathery old globetrotter!' And he lies down on the nets, locking his hands behind his head.

Tobias opens his rucksack and unrolls two woollen rugs that were tucked under the flap, one a green-and-blue check, the other mustard coloured. 'Take that,' he says, offering one of the rugs to Raphael, 'it's lightweight, but very warm.'

Each of them wraps himself up in a blanket. The dog curls up at Tobias's feet.

For a long time they lie still, on their backs. They listen to the

wind, contemplating the patches of sky in the ceiling, turning from turquoise, to slate, to petrol blue. Tobias thinks of his father with a mixture of pity and sorrow; he feels oppressed.

'You're panting like a man running round in circles,' says Raphael. 'What are you getting so winded about?'

'I can't sleep, that's all.'

'Maybe because it's the first time you're spending the night away from home? Try to match your breathing with that of the sea breeze, listen to how it blows, in complete freedom, combining strength and gentleness . . . nothing bothers it, it sweeps on, constantly weaving its song . . .'

'A strange song! Very monotonous, and rather disturbing after a while . . .'

'It depends on your ear,' Raphael interrupts him. 'I hear an expansive and playful song, almost laughter. Inexhaustible, irrational laughter, of the kind that often overcomes people who are madly in love and can't find words equal to their passion, or those who've come close to death and discover they've been spared, then relish life in the raw.'

'Yet newborn babies don't exactly come into the world laughing! Initial contact with life is downright unpleasant, even brutal. As for the death-bed experience, most of the time that's worse still.'

'All the more reason to seize any chance of laughter between the cradle and the grave. But it seems to me that you're not much of a poacher when it comes to laughter.'

'There hasn't been much opportunity in the last fifteen years.'

'I know, Tobias, I know, but the laughter I'm talking about is of a different quality from that normally associated with laughter. Anyway, let's drop the subject. I'm going to stop talking, and hand over to the wind, hoping that you'll listen to the modulations of its voice with a more attentive, more receptive ear . . .'

Tobias keeps his eyes open in the dark for a while, and his ears strained. Slowly his breathing grows calmer, falling into rhythm with that of the night, of the ocean. He thinks about the shadow-child who appeared on the path a little earlier and settled his unconsoled gaze on him. And a doubt creeps into him: it could be that he has been too hasty in deducing his fate, that he is wrong in believing himself to be condemned, like his father, his grandmother Rosa, his aunt Valentine, to a life ruled by melancholy. He senses that there is no definitive, unavoidable law of destiny. As the wind blows through him and lays him bare, his angst gradually relaxes its hold.

When at last he falls asleep it is completely dark. The tide is coming in; soon the water will be licking the stilts of the walkway, it will swirl under the floor of the cabin and lull the two sleepers, then it will carry their dreams out to sea. And during this time Valentine too lies asleep, on the grass in a meadow, she too is being carried a long way out, out of time, out of herself and her fear, while Arthur prepares to celebrate a fiery wedding, scattering roses and waterlily-flames on the slow-moving waters of the fens.

They wake at dawn. The shadows in the cabin are dispersing, the holes in the corrugated roof and the gaps in the walls are tinted pale pink. The sea, which has risen to half-way up the stilts during the night has already begun to ebb again. They get up and go out on to the deck, followed by the dog.

'Do you think the dipping net still works?' asks Tobias, examining the big square net hanging askew in the air.

'Let's try it, and see,' replies Raphael, and he fiddles with the handle before turning it. The net sways, and after a few lurches it is lowered down to the water that covers the mud; the handle produces shrill squeaking noises that make the dog bark. They leave the net in the water and go back inside the cabin to pack their belongings. Raphael takes one of the

buckets standing in a corner and finds a broken-handled landing net. He mends it with a piece of wire.

'This is in case we've any visitors, a fish, a crab, or, who knows, even a message entrusted to the waves . . .'

They go outside again, rest their bags on the deck, and walk over to the dipping net. Raphael turns the handle again, which squeals even more loudly, the net jerkily makes its way up, swings, stops, rises a little, drops back, resumes its ascent. Finally it reaches the level of the deck.

'I think we've got ourselves a fine catch!' exclaims Raphael. 'Quick, Tobias, the landing net!'

There are a few crabs in the net and a large, struggling, white-bellied fish with a blue-grey back, which is thrashing its tail in all directions.

'Catch it, Tobias, hurry up! The net's all torn, the fish is going to escape . . .'

Tobias, who has never fished like this before, busies himself as best he can.

The fish puts up a fight, makes sudden leaps in the net, which lurches, and the dog leaps around just as energetically, yapping and getting between the two fishermen's legs. Tobias finally captures the fish and throws it into the bucket that Raphael is holding out to him.

'It's a magnificent conger eel,' says Raphael, 'one that's still young. Go and see if you can find a piece of paper or plastic in your bag or mine, and bring me the salt as well.'

In the time it takes Tobias to go and fetch the salt and a plastic bag, Raphael has killed the eel, which is lying on the deck.

'I've done the dirty deed, the rest is for you to do. Cut it open, take out the tongue and the heart, and remove the entrails as well, the dog will be happy to eat them.'

While Tobias gets to work on the fish, Raphael fills the bucket with water, then, once the eel is gutted, he cleans it and wraps it in the bag. As for the heart and tongue, he puts them

in a little tin box, covers them with salt, and hands the box to Tobias.

'What am I supposed to do with that?'

'Everything, the whole of life, is an exchange, in infinite ways, some that are obvious and concrete, and even more that are subtle and intangible. We'll grill this fish a little later, the heart and tongue are to be kept. When the time comes, I'll tell you what to do with them. But now let's go for a swim. It's too muddy here, we'll go to a beach not far ahead.'

And they set off again, following the narrow chalk-coloured path, skirting the void, in the expanse of dawn. They do more than just walk, they quietly tread upon the light that slowly wells up from the horizon, they breathe in the emptiness around them, they move at the break of day on the confines of land and water: two tightrope walkers gliding on the surface of the sky. The dog frisks about beside them.

THE ARTIST'S STUDIO

So he brought them to the house of Raguel,
whom they found seated by his courtyard gate.
They greeted him first. He said to them, 'Greet-
ings to you too, brothers! Good health to you,
and welcome!'

The Book of Tobit 7: 1

They reach the port of La Pallice, a place which, at that early hour of the day, seems no less desolate than fantastic, with its large ships along the quayside guarded by colossal-looking cranes, its huge silos, its disused areas, and at the far end of the wet dock, an enormous mausoleum of blackish-grey concrete. This was the bunker built by the occupying forces during the last war, bombarded now only with bird droppings. Tobias and Raphael wander for a while round the still deserted port, exploring the quayside, the breakwater, the dry dock, then resume their walk into town. They stop on the way at a little beach suitable for swimming, not far from a redoubt left with only its memories of past wars to guard.

Redoubts, ramparts, towers and fortresses – they keep passing these as they go down the estuary, like starfish or shellfish in grey, white or yellow stone, standing sometimes on islands and islets in the middle of the sea, sometimes along the shore, or collapsed in the silt, and surrounded by marshland. A Vauban's or a Montalambert's concern for elegance was in no way shared by the Kriegsmarine who left behind nothing but soot-coloured blockhouses with all the charm of a mastiff.

On the fifth day of their trip they arrive in a little town overhanging the estuary. Raphael suggests they stop here. In the evening they dine on a restaurant terrace. Since there are not many clients, the waitress takes the time to chat and having given them a detailed commentary on the menu – a menu nevertheless limited and rather uninspired in the choice on offer – she starts gossiping.

'You've come to see the caves, I'm sure?' she ask them as she brings a carafe of wine.

'Yes, we're planning to visit them,' says Raphael. 'There are

lots of stories about them, legends of shipwreckers . . .'

'Ah, yes, now that's worth talking about!' exclaims the woman whose eyes suddenly shine as brightly as the treacherous fires lit by shipwreckers in the past, to lure ships to their doom on the rocks. 'People now claim it's all just legends, as you say, made-up stories, but that's not true! There really were pirates, outlaws, sorcerers too, who lurked in caves along the cliff, like octopus, or snakes, and they did nothing but evil. And not only is it more than just a yarn, it's still going on!'

Having delivered these last words in a tone full of innuendo, she falls silent for a moment the more to excite the curiosity of the two visitors. But Tobias woefully disappoints her expectations by asking, 'Could you bring us some bread, please?'

The waitress looks a little peaked and goes back to the kitchen.

Raphael then bursts out laughing.

'What's so funny?' say Tobias in amazement.

'You,' replies Raphael, filling their glasses with red wine. 'The waitress was on the point of confiding some scandalous secret, she was building up the suspense, and something tells me she's an expert in the art of tittle-tattle, but then, you great dope, you go and ruin the whole thing by asking for some bread. Come on, let's drink to the troglodytes this woman has such a low opinion of!'

The waitress returns with a basket of bread and Raphael hastens to rise to the bait she has thrown them.

'We interrupted you just now. You said it was still going on. What do you mean? Wreckers?'

And the woman's eyes began to shine again. 'In a way, yes, but it would be more true to say a woman wrecker, a witch! For it's a girl that's to blame, worse than that pirate who would take a black ram out at night with lanterns hanging from its horns to mislead sailors, worse than the sorcerer of Matata . . .'

'Then she must be very beautiful,' says Raphael.

'Beautiful, yes,' the woman concedes, pouting with scorn, 'but a lot more dangerous!'

'What on earth has she done?' asks Tobias.

And the reply is delivered with dramatic effect. 'She kills! Yes, gentlemen, that's what she does. She kills young men!'

'With steel blades, bazooka, poison, or chainsaw?' asks Raphael ingenuously.

'You don't take me seriously, but you're wrong! As a matter of fact, it's boys your age that she murders, there have been at least three in this area alone . . . she's actually left many more dead than that!'

'But if she's guilty of so many murders, why hasn't she yet been arrested and locked up?'

'Well may you ask! The fact is she's no ordinary criminal, she's a witch, a real witch! She doesn't use any weapon to kill, she leaves no trace, she entrances, she casts spells, and her victims meet with a violent, sudden death that always passes for an accident.'

'But what proof do you have that she's responsible for these deaths?'

'I know, that's all. Besides, everyone round here says the same.'

'She lives near here?'

'Yes, worse luck! Look, straight out in front of you, over in the direction of Talmont, on the cliff-face. That's where she lives, within the very rock. Some of the caves have been turned into houses. Her father's a painter, his studio overlooks the estuary. When the sun catches the windowpanes, they sparkle, then you can see the glass quite clearly from here. The eye of a shipwrecker!' With her hands planted firmly on her hips, the woman aims a scowl at the witch's lair, then after a silence heavy with anger, she adds, 'Really, the very idea of living in a cave! It's all right for savages and bandits, for wild beasts, but not for civilized people. Can you imagine, those

ancient dens of robbers and sorcerers must be thoroughly pervaded with evil spirits, with malignant vibrations! And that girl, who's lived in that place her whole life, must be steeped in all that black magic! In my opinion, that's the source of all the harm . . . besides, you should see what that father of hers paints! Not a pretty sight, especially not recently, you'd think they were all possessed! It's not painting, it's butchery. They're all going to end up as mad as hatters in those caves! They ought to be blocked off, those caves, and the people evicted from them. As for that man-slayer, she should be walled up in her lair, like the sorcerer of Matata three hundred years ago.' She ponders on this, and crinkles up her eyes.

'You know this young girl well?'

'I certainly do, I worked for her parents for several years, I did their cleaning. But I handed in my notice not long ago, what with all those tragedies that happened. I got a job here for the season. I wouldn't go back to those people, not for anything in the world. Would you like a dessert?'

Tobias stares at her in surprise, so sudden is the change of subject.

'Apple tart or lemon meringue pie, chocolate mousse, fruit salad, crème caramel or sorbet . . . ' the waitress rattles off, getting back down to business.

'What's this painter's name?' asks Raphael.

'Ragouel, he's called, and the daughter's Sara.'

'We'll just have two coffees,' he says to end the conversation.

And it is to a cave they repair to spend the night, heedless of the gossip they have just been hearing. Squatting near the mouth of the cave, Tobias watches darkness fall on the waters of the estuary, and when he catches sight of a slim figure walking over the rocks along the shore he is suddenly reminded of Deborah. She might well have lived in a place like this, he says to himself, in the cliff-face; she might well

have lived anywhere, in fact, on a raft, in a tree, out in the desert, in the heart of a city . . . She was so much an exile, and had so few needs. It did not much matter to her where she ended up, she carried within her the land of her birth, of her childhood, of her ancestors. And far more than that, she carried within her a vanished world, a world whose silenced voices and songs had continued to resonate in her heart in tune with the most arid, strident silence of that God she had never denied or forsworn, but endlessly appealed to and questioned. At that moment he so wished that the figure he could see down there, slowly fading into the darkness, was that of Deborah, or of his mother. He misses both of them, his sense of loss deep and murmuring like the estuary whose waters gleam with muted lustre.

'Are you dreaming, Tobias? You look like a bat about to take flight,' says Raphael.

'I was thinking of my grandmother.'

'The fact is that she's always with you, invisibly. The bonds of love, of responsibility, are not loosened by death, they re-establish themselves differently, mysteriously. There are occasionally moments of grace, like this evening, when we come into fleeting contact with the dead, and are visited by their presence for the duration of a sigh, a glimmer . . .'

'Have you lost anyone?' asks Tobias.

'I've seen many people die.'

'Close relations?'

'Everyone's a close relation to me, especially in the hour of death, they're so destitute then, more often than not.'

'I think Deborah went to her death with total clear-sightedness, and great calm. She prepared for it as though for the welcome of an honoured guest, but at the time I didn't understand that. And besides, she was so old, I thought of her as immortal.'

'You were not mistaken, except it's not a matter of age, but of heart and spirit.'

'There is one thing, though, that I've never understood and probably never will: the day before she died she said to me, "May God liken you to Mejdele." I have no idea who she was talking about.'

'Perhaps it's the secret name of the enduring strength that resided in her and sustained her, the name of her inner core. Your task is to find the path that leads to that name.'

Tobias peers into the darkness looking for the figure he glimpsed a little earlier, but it has disappeared, merged into the rocks.

He sits at the edge of the cave as Deborah once stood at the ship's stern, still and attentive; he is the same age as she was that night, now so distant that it has become timeless, during which a bright and fleeting vision of the goat kid appeared in the middle of the Atlantic.

'Look,' he says as he gets up to go and lie in the cave, 'a light's just come on in that studio window the woman pointed out to us earlier. That painter must work at night.'

'Unless he waits until it's dark to commune with the paintings he's done during the day,' replies Raphael, already stretched out on the ground, his arms folded behind his head. 'There's a time to be creative, and another to meditate, to have doubts, to question . . . You know, this Ragouel is a very interesting painter, I've seen some of his work in galleries, and some reproductions. I made a note of his name. I'm delighted the waitress showed us where he lives. I'll pay him a visit tomorrow, at least I'll try. I'd very much like to meet him, to see what he's painting these days . . .'

'But he doesn't know you,' objects Tobias, 'and I doubt if he wants to be bothered by a stranger.'

'I can be very persuasive if need be! You didn't know me any better when you agreed to accompany me on my wanderings, did you?'

'True, but . . . there's that strange girl . . . I don't think we want to run into her.'

'Don't talk nonsense about that young girl, there are already enough malicious gossips making mischief. We'd better go to sleep. We have a lot to do tomorrow; we'll try our luck!'

Ragouel is in his studio, standing behind the large windows. He knows that Sara has gone down to the beach, as she now does every evening. Nothing but the subdued murmur of the water can soothe her. She only goes out at nightfall, slipping through the twilight – hardly a nightbird stirs as she furtively passes by. All day she remains confined to her room, with the shutters half-closed. She is afraid of the light, on her face, on her body. She is so afraid of being seen. She has lost all appetite, even for living. She does not talk any more, she is immured in silence. Maybe she has also come to fear her own voice? What if she were reduced to dreading even her own breath, and made it fail?

Ragouel keeps watch in the darkness over his daughter, over that body of shame and terror, lying on the black seaweed. He knows that she is the victim of some spell, even though he has no understanding of it. And he senses that she is in great danger. Death that has struck violently seven times in her wake, as though transmitted by her beauty, is now turning against her, prowling round her heart and secretly consuming it. When the air gets too chilly and damp, Sara will return to the house, sneak back to her room without a sound. But what if she did not come back one evening, if she let herself be carried out by the tide? Ragouel is in a constant state of alarm, and so too is Edna who secretly weeps behind another window.

He moves away from the window, lights a cigarette, paces round the room. Before, he always used to keep his studio clean and tidy, he liked it almost empty, but now disorder is left to reign, to spread. Crumpled and torn pieces of paper on

which he has sketched figures are strewn across the floor; there are also photographs and reproductions of all sizes lying about. He walks over this jumble of images covering the ground. They are mostly photographs of his daughter and reproductions of the two painters whose work and genius haunt him, Caravaggio and Francis Bacon.

For a long time Caravaggio dominated his work. Ragouel trained his eye in the impassioned and detailed study of Caravaggio's paintings; he mastered for himself the violent, splendid way in which that artist dealt with the visible world, with things and people, transforming into the supremely beautiful what tradition deemed contemptible, tackling objects, faces and bodies like a wrestler struggling with his adversary, plunging them into obscurity, as if it might have been a flow of black lava, and then striking them on the forehead, on the temple and cheek, on the lips, shoulders and hands, on the belly, thighs, knees or genitals, with a violent beam of harsh light glancing the skin, making incandescent the mystery of the flesh. For more than twenty years Ragouel painted in a style influenced by this artist, in a combination of affiliation and brotherhood; he in turn launched himself into the battle with shadow and light, in which what was at stake was the flesh. The flesh of human beings, always to be wondered at, whatever its condition, its age; fine defiant flesh, filled with strengths, desires, deliriums, but also doomed to overindulgence and decline, doomed to decay.

But since his daughter has fallen prey to some malignancy neither he nor anyone else can explain, the look in his eye has changed, hardened, as if haunted. He has in no way rejected his first master, Caravaggio, but his attention is now concentrated on particular works of his – all those representing a cry. For Ragouel senses an immense and frantic cry contained in Sara, brewing and moaning inside her without daring to break out, to acknowledge her rebellion, her anger. Sara is innocent, and yet seven times she has brought death to very young men.

Sara has a pure, bashful, generous heart, but her beauty is that of a sphinx, her mouth sows death. Sara is possessed, her young girl's body taken over by some evil force from which no one, nothing seems able to save her, and she is letting herself waste away in silence, in order to destroy the unknown power that has taken up residence inside her.

Ragouel tries to translate this cry of despair imprisoned in Sara, he wants to force it out of her body through the magic of painting. That is why he has selected from among Caravaggio's work certain pictures featuring a cry. There is the 'Medusa' painted on a small shield whose head covered with writhing snakes looks as if it is about to leap out of the curved mounting on which it is depicted. Her mouth is wide open, black, her eyes huge, enraged; blood spurts in dark red jets from her cut throat, her head suggestive of an apocalyptic sun. There is the 'Sacrifice of Isaac', in which the child is screaming, refusing to be sacrificed, his cheek crushed against the stone of the improvised altar; Ragouel holds his brush the way Abraham holds the knife, in the hope of a miracle. There are portraits of David holding up the head of Goliath, the latter with a hole in his forehead like some third eye, and grimacing with rage, astonishment, his mouth clotted with shadows. There is Judith decapitating Holofernes beneath a red canopy and the fascinated gaze of an old serving-woman with a wrinkled profile, convulsed with disgust, hatred and avidity; the red of the curtain is picked up again in that of the dying Assyrian soldier's tongue, and of his blood spurting in long streaks that underscore and detract from the blade of the knife. There are also pictures of Christ taken down from the Cross, with blue-tinged lips, heads of John the Baptist whose mouth bites into a morsel of darkness; but above all there is the extraordinary 'Taking of Christ'.

The cry here is more suggested than predicated, it is shown sideways on. Only Christ is presented full-faced, all the others, soldiers and disciples, are in profile, including Judas, planting a

brutal kiss on Jesus. All that is visible of the two soldiers, encased in armour, are the nose and a cheek, their eyes are in a band of shadow beneath the visors of their helmets; they are not really men of flesh any more, but of gleaming metal with touches of gold and reflections of light, men with rhinoceros heads and crab arms. Behind them, on the right of the canvas, a man's face emerges from the darkness, he holds up a lantern in his hand to try and throw some light on the confusion, on this treacherous embrace combined with a tight grip. The raised hand is counterpointed by Christ's hands, with his fingers intertwined, interlocked, right down at the bottom edge. Strong lines and curves spatially define the painting, imparting an energetic circular movement.

But most remarkable of all is the group gathered on the left, composed of three faces linked to each other with a rapid syncopated rhythm that gives the image a sequential, almost cinematographic conformation. Judas, with his brow all creased, furrowed with immense anxiety, his gaze consumed with doubt, crushes his lips to Christ's cheek, while clutching him by the shoulder, and Christ's head sways slightly to one side under the impact of this kiss by which friendship, trust and hope are all simultaneously dashed. And the face of the betrayed and outcast master expresses equal weariness and sorrow: the very darkly drawn eyebrows and the lowered eyelids deep in brown shadow set off the pallor of his brow and nose, caught in the glare of light. And with his back to Christ, actually seeming to form part of Christ's body, is that young man in profile, with his mouth wide open, the fingers of his hand widely splayed, flung forward into space. He lets out an immense cry into the darkness, a cry whose source is Judas, and which has passed through Christ before flooding into his witness body, his gaping mouth and thrown-up hand with exposed palm. In his gesture of panic the end of the robe he is wearing is sent billowing up in the air, and it floats above the three heads clustered together, surrounding them with a red

halo that flaps in the wind blowing in the garden, the wind of disaster.

Ragouel has so often studied this painting that he has eventually discerned the shape of a mouth in the red cloth that haloes the three-headed body; a strange mouth, like that of a fish, a kind of giant scorpion-fish. A mouth only slightly open, but ready to swallow up all the characters in the scene.

This painting fascinates Ragouel more than any other. He sees in it a transposition of the tragedy bearing down on his daughter. Sara is at the same time the one whose kisses bring death, insidiously and violently; she who endures this fatal treacherousness; and finally she who bears in her flesh a terrible cry of distress, of appeal for help and deliverance, and also of rebellion. He is as much haunted by this painting as Francis Bacon was for a long time obsessed by Velasquez' portrait of Pope Innocent X.

He would like to perform the same disturbing miracle as that achieved by Bacon in transfiguring, and disfiguring his model whom he places on a throne as terrifying as an electric chair; apparently weightless and at the same time rooted to the burning seat, the body has powerful currents, violent shocks, ripping and rippling through its flesh and nerves, and even through the fabric of its papal robes. And he screams, his mouth is a black chasm. A painting in which the visible becomes strident, shrill, while yet remaining silent.

Ragouel wanders back and forth between Caravaggio's works and those of Bacon, between the crying-out faces of the one, and the distorted, convulsed faces of the other, between shadow pitted with pools of intense light and vast expanses of acid colour in which bodies in extreme tension, corrugated forms, fluid-like fluctuating carcasses flow, writhe, embrace each other. He tackles virgin canvases without respite, using brushes, rags or his bare hands, working the paint with his

fingers, to hunt down the dark secret lurking in Sara's heart and throat, but to no avail. He never succeeds in ousting the cry buried in Sara like a snake distilling its poison drop by drop, and which will eventually kill her. Probe as he might, into images, paint, colours, delving every which way into the mystery of appearance and of the flesh, he fails. And he reflects on what Bacon said about being dissatisfied with all the variations, astonishing as they are, that he had created of the Pope portrayed by Velasquez.

'I wish I hadn't done it. When I painted the pope screaming, I didn't want to do it in the way I did: I wanted to make the mouth, with the beauty of its colour and everything, look like one of the sunsets or something from Monet.'

But Bacon also said, speaking of his passion for gambling and, in the same breath, his passion for painting: 'I feel I want to win even if I always lose.'

Ragouel smokes and slowly paces round the studio, his feet crushing the sketches and reproductions scattered across the floor, cigarette ash falling here and there as he wanders about, making the sheets of paper slightly grey. He directs piercing glances at his work in progress and the canvases he has recently finished, as well as at the reproductions of works from which he hopes for some revelation, and the photographs of Sara. He keeps the images under observation, on the lookout for a chance sign. The vision he awaits might appear at any moment, a coruscation on the ground strewn with trampled images, or on the picture-crowded walls. He wants to succeed, to arrest that cry, to capture it in a painting, and deliver his daughter. He must, as a matter of urgency.

Every evening Sara goes down to the beach, lies down on the rocks that are slimy with seaweed and moss, her forehead pressed to the sky, to empty space, her lips sealed on her unhappiness. She is expiating a wrong committed through her, against her will. She cannot, will not go on like this, living

the life of a recluse, a pariah. As she dares not take her own life, she appeals for death, awaits it imploringly. She hopes the tide in the estuary will rise high enough to carry her away, that she will be swallowed up by that enormous open mouth between the cliffs and the marshes, and that the cry devouring her heart, rending her conscience, will be lost in the sound of the water.

But this evening she did not linger on the shore, she sensed a gaze close to her in the darkness, the gaze of a man seeking her among the rocks. A gaze coming from the cliff-face, like a seabird escaping its chalky nest to let itself be carried by the air currents, to glide silently through the expanse of night. She felt a hunted prey, but she knows how disastrous it is for her to be thought of in this way. So she fled, quietly, swiftly, and returned to her room.

Ragouel and Edna have heard her come in, and their anxiety has slightly relaxed. And with a last glance at his easel Ragouel is stopped dead in his tracks, just as he is about to leave the studio. All of a sudden he is under the impression he can detect a vague smile in Sara's portrait, which he has been working on for days. He has tackled it in the manner of Bacon's self-portraits and the series of portraits Bacon painted of his friends; not from life, but from memory and photographs, recovering his own perception, all passion and tension, of those men and women he painted in their absence, thereby allowing shapes, movements, accidents of line and colour, visual forces suddenly to emerge, as if the pictorial matter was itself erupting, pouring in streams of orange, red, pink, yellow, vermilion, chilly mauve; as if flesh and painting were of one sole matter, intense, quivering, combustible. The faces are disturbed by an inner squall, their features disarranged, twisted, profiles, frontals and three-quarter profiles are superimposed, collide with each other, interpenetrate. And these impromptu portraits are powerful in their spontaneity, their

apparent improbability, whose verity is no less striking than bewildering.

In this portrait of Sara, Ragouel once again strives to capture a fitting expression for that ringing cry which has become the sole objective of his painting, but the mouth, although distorted, skewed across the face and tarred with reddish darkness, seems bizarrely to be giving the ghost of a smile.

'I always wanted and never succeeded in painting the smile,' Francis Bacon revealed one day. Ragouel is astounded that he has managed to suggest a smile when he was trying so hard to convey the violence of a scream, to extract, like a mineral from the rock in which it is embedded, a brute cry. He does not understand how his hand can have so betrayed his intention, how his endeavour can so radically and ironically baffle him.

'It may look different tomorrow,' he says to himself, as he leaves the room and switches off the light, 'in the daylight, after a night's rest . . .'

But the next morning, far from having diminished, the ambiguous expression of a smile seems more pronounced. Ragouel examines his canvas from various angles, steps back from it, goes right up close. The smile persists. There is no hint of a cry. The face floats on the yet uncompleted canvas, and the wounded mouth, filled with shadow, still refuses to cry out. It seems rather to breathe a sigh of great weariness, a kind of deep astonishment, not without gentleness. Taking his inspiration from Caravaggio's work, above the face he has painted a cloth that is supposed to be flapping in the violent wind connected with the rebellion and deliverance of the person portrayed. But as in Caravaggio's painting which he has so closely studied, the arc drawn by the fabric and the deep dark fold in it suggest the mouth of a giant fish; a fish surfacing from the very depths of the sea, rising slowly above the scene

depicted and suffusing it with a silence no less compelling than unexpected. Ragouel searches among his jumble of images for the reproduction of 'The Taking of Christ'; he studies it again, admires the dynamic of the composition, so strong and concentrated, the way the hands of the protagonists in the drama are brought into play, and the group of three faces in which the process of Judas's deadly kiss is broken down: a kiss more chilling than darkness, suffering, terror, or cry.

But perhaps another face is hidden behind that triple head, perhaps the cry uttered by the disciple is going to develop differently in the dark night in which the scene is immersed, and resolve itself in silence, or in song? Ragouel does not know what to think any more, does not even know what he is seeing. It is no longer he who captures and transcribes the visible, it is the visible that sinks its claws into him and unleashes a rush of emotions, sensations, thoughts and visions, each more disconcerting than the other. As he hangs in doubt, totally perplexed before these images, Edna opens the door into the studio and tells him there is someone on the phone asking for him.

Raphael and Tobias arrive at the house in the mid-afternoon, exactly on time for their appointment with Ragouel. He is at the door, looking out for them. He comes out to meet them, welcomes them and invites them into the house.

THE OCEAN TOMB

But Raguel got up and summoned his servants.
With him they went out to dig a grave, for he
said, 'I must do this, because if Tobiah should die,
we would be subjected to ridicule and insult.'
When they had finished digging the grave,
Raguel went back to the house and called his
wife, saying, 'Send one of the maids in to see
whether Tobiah is alive or dead, so that if neces-
sary we may bury him without anyone's know-
ing about it.'

The Book of Tobit 8: 9–12

Ragouel leads his visitors to the sitting room. This does not look out over the estuary, but faces the garden. They sit round a low table, in high-backed armchairs covered in straw-yellow repp. Paintings of various dimensions, in carved wooden frames – brown with reddish tinges or subtly gilded – are hanging on the walls. They are all works by Ragouel influenced by Caravaggio. There are a few nudes, some portraits, some street scenes and bar scenes, displaying an unusual combination of the sacred and the profane, with a quiet hint of mockery at the core of the pathos always stealing in.

Several apertures let in the light: a narrow casement window, and just in front of Tobias, halfway up the wall, a little oval window, and right above it a skylight in the sloping ceiling.

'This house was built in several stages,' Ragouel explains, 'one part of it stands firmly on the ground, while another is built into the side of the cliff and includes what was once a cave, which I've turned into my studio.'

'A lot of legends about those caves are still being told,' says Raphael.

'Yes, they give rise to idle fancies or gossip, depending on people's frame of mind. I like it here. Actually it was mostly the poor who took refuge in them in the past, fishermen, tramps, and also Protestants during the religious wars.'

'What about the stories of shipwreckers?' asks Tobias, without daring to mention those of witchcraft.

'A load of rubbish!' retorts Ragouel. 'Until the eighteenth century there were no lighthouses to speak of on the Atlantic coast, as for the use of fires at sea or on the shore, it was very rare, and any light shining in the dark would have inspired wariness or even fear in sailors rather than attracted them like

butterflies. But it's romantic, so the truth gets embroidered, everything gets muddled . . .'

Edna comes and goes, bringing coffee, cakes, wine for an aperitif. She is the one who made the picture frames, decorated the sitting room; it is she who attends to things here, to the space, the light. She is the guardian of the place, discreet in her manner and words, and yet a great sensuality emanates from her; her gestures are graceful, the way she moves feline, and her gaze at once caressing and shy. But right now she is mostly worried about her daughter: when Sara heard that two visitors were on their way, she went rushing to her room and is waiting in anguish for them to leave. Edna secretly observes these two strangers, not sure that their arrival is not motivated by some obscure reason other than the one they gave, of admiring Ragouel's works.

Despite his own anxiety, Ragouel is happy with this unexpected visit. When Raphael spoke to him on the phone, he felt that for once chance was proving auspicious by sending him someone who might help him out of the confusion he was in with regard to what he was currently working on. Ragouel is no longer sure of anything, not only his painting, but his own eyes. He sets out to capture a cry of deliverance, and it is a wan smile that appears on his canvas, his hands perform contrary to his will, and he is bewildered by such defiance of expectation. He hopes that this man, whose remarks were so apposite and judicious when he introduced himself and expressed the desire to meet, will be able to bring a penetrating, excoriating eye to his work in progress, with which he is getting nowhere. And indeed the conversation soon turns to painting.

Outside the wind has freshened. Tobias is not taking part in the discussion, he lets his eyes wander round the room. He listens to the sound of the wind blowing in from the sea and he gives way to a daydream that slowly changes his visual

perception and stirs all his senses, disturbs his imagination. In front of him, hanging over the armchair in which Raphael is sitting, is a big rectangular painting depicting two women seated side by side, one seen from behind, the other looking out. It could be the same model in two different poses, presenting herself nude from the shoulders to the small of her back and buttocks, and from her throat to her knees. She is a young girl with beautiful heavy breasts, a rounded stomach, full thighs. Her flesh is a pearly white with pale pink highlights. She holds her face slightly to one side and lowered, and her arms lifted above her head form a pale lozenge framing her black hair that falls to her armpits. Her pubes is only tentatively suggested, with the hint of a dark triangle below her stomach, where her thighs meet.

There is another, invisible triangle, although at each of its points the visible is vibrant and aglow. This triangle links the painting with a mirror on the wall in the corner of the room, in which the frontal nude is duplicated, reduced to torso and thighs; and with Tobias's eyes, which stare now at the painting, now at the oblique reflection. His eyes too act as a mirror, a burning mirror that sets the image ablaze. And his gaze sharpens, darts like a crazed insect from the painting to the mirror, from the mirror to the painting, plundering the naked body, searching the canvas, searching the glass. In a mixture of panic and secret pleasure he feels a feverishness stealing over him.

And then a third triangle opens up, this time to the right of the painting, linking the nude with the fanlight and the little oval window. The wind whips up the sky, racing clouds of silky but acid white skim the fanlight windowpane, flights of frenzied birds pass by, screaming. Clouds and birds seem to rise out of the naked girl's hair: these are her mingled dreams, thoughts, fears and desires taking flight. Clouds and birds rush into Tobias's body, swim in his blood, whirl round his heart and burn in his loins. But the oval window behind which

shrubs and branches sway and writhe is far more disturbing yet; Tobias sees in it, in full light, what the painting only scarcely shows: the young girl's pudenda, the soft, voluptuous, ultraviolent secret of her body in which all is dance and pulsation.

Tobias's gaze keeps exploring these two triangles, that on his left by the mirror, that on his right by the windows, to superimpose them, break them up, recompose them, rotate them to get nearer to the first, half-buried, unmoving triangle. He would like to move apart the thighs of the young girl in the painting, stroke that flesh rippling with shadow and light, feel it, penetrate it. He would like just as much to part the girl's hair, lift her head, hold her face in his hands and look her straight in the eye, and kiss her. But the young girl, while exhibiting her delectable flesh, hides her face and conceals her cunt. The clouds scurry, the birds fly past screaming, the trees pitch and wave their branches. The wind – a very strong sea wind, a carnal wind – blows round the house, assaults the cliff, and probes the sitting room, moaning along the walls, making the images, the reflections quiver, and whirling inside Tobias until he is dizzy.

'Hey, there, Tobias, are you lost in a dream?' says Raphael getting up out of his armchair. Tobias is startled, gazes at his companion distractedly. He has not listened to any of the long conversation the two men have been conducting, he has not heard the suggestion Ragouel has just made that they visit his studio.

'Do you like that painting?' Ragouel asks. 'It was done a very long time ago now, almost twenty years . . .'

He does not say that the model is none other than his wife Edna, painted at the time when she was expecting Sara, during the first months of her pregnancy.

'I don't paint in that style any more,' he adds, 'but I'm still very attached to that canvas. In any case the only paintings on

display in this room are ones I did years ago. If you like, I'll show you what I'm doing now . . . at least, what I'm trying to do.'

Ragouel halts at the threshold of his studio. 'Right now there's something that's giving me a lot of trouble, my own painting has become an enigma to me, the visible slips between my fingers . . . so I'd like to know what you think about a picture that's playing strange tricks on me, but it would be better if you gave me your opinion separately so that you aren't influenced by each other . . . I so badly need to understand.'

'You go first,' Raphael says to Tobias, 'I'll wait here.'

Still dazed by his fervid reverie in the sitting room, Tobias goes into the studio. Ragouel points to the canvas on the easel.

'What do you see?' he asks.

'A face . . . a face of mud, of grey and bluish clay, with a dark smouldering in its mouth. I don't know.'

'Look, look again,' Ragouel insists. 'Don't you see anything else, don't you hear anything?'

Tobias studies the painting carefully, and eventually says, 'I don't hear anything, no. It's a great silence rather that's conveyed by this face, and the mouth seems to be giving a hint of a smile . . . yes, a smile, even though there's something uncertain about it, and sorrowful too. But I could be mistaken . . .'

'It's not you that's mistaken, I'm afraid,' replies Ragouel in a suddenly toneless voice, 'it's just me. Thank you.'

'Why do you say that?'

'I wanted to paint a cry, the result is that poor doubtful smile!'

Tobias remains for a moment in front of the canvas, intrigued. A very singular beauty emanates from this clayey, distorted face, and the violence in it mysteriously bears the promise of calm. An incongruous association suddenly

establishes itself in his mind: he imagines this is the face of the young nude in the sitting room.

'It's her . . .' he murmurs.

'Pardon?'

'You should leave this painting the way it is,' says Tobias, recovering himself. 'It's very beautiful in its incompletion, its expectation.'

'Expectation? Of what?'

'Nothing, that's the point. Nothing definite. I don't know.'

But he does not speak of the deep emotion he experiences before this portrait, which intensifies, purifies the blaze of desire that overcame him a little earlier.

Tobias goes to fetch Raphael, who is waiting in the corridor. Raphael in turn enters the studio. Tobias does not follow him. He needs to be alone for a few moments, and he is thirsty, he would like to have a drink, to immerse his face and hands in cool water. But he does not know where the bathroom is. He knocks softly at a door, opens it a fraction, it is only a cupboard. He continues, knocking on a second door, opening it cautiously; it is a bedroom. Before he has time to close the door again, he sees a young girl leap up in the middle of the room and immediately back away towards the wall opposite. She has big eyes of violet blue, a very pale complexion, black dishevelled hair. Without thinking, Tobias walks into the room.

'It's you!' he exclaims under his voice. He is thinking of the sitter for the nude painting and the portrait. He combines the two images, blends them together, wonders at seeing them in the flesh, at having traced them to the source. But the young girl is flattened against the wall, she even seems to want to bury herself in the wall, to disappear into it. She raises a hand to her mouth to stifle a cry, her eyes glisten with tears and distress. But Tobias is incapable of reacting, he is no longer master of himself; he is not drifting in a state of reverie any

more, he has entered the arena of an all-powerful dream that submerges reality. And he takes another step forward, repeating, 'It's you!'

'Go away!' the young girl finally begs in a breathless voice. 'Get out of here, otherwise it'll be the death of me . . .'

Standing motionless by the doorway, he gazes at her in silence, smiles at her, as one who has found someone dear to him after a very long absence, someone patiently awaited, then he creeps out and quietly closes the door.

'Apparently we had the same reaction to Ragouel's latest painting,' Raphael says to Tobias as they leave the house in the late afternoon. Tobias has no desire for a discussion, no thought of one, he is extremely agitated and at the same time he feels exhausted.

'Yes,' Raphael goes on, 'we both saw a smile where he had been striving, doing his utmost to paint a cry. He talked for a long time.'

'About his daughter?' asks Tobias, emerging from his silence.

'No, about Francis Bacon. He's fascinated by that artist. And about Caravaggio too, about one of his paintings in particular, 'The Taking of Christ'. His reading of the picture is cinematographic, he sees it almost as a detective story – he'd like to capture the cry emitted by the disciple into the darkness of Gethsemane, he detects optical illusions, suspects that the scene extends beyond the canvas . . . hey! Are you listening?'

No, Tobias is not listening, he does not even hear him. He wants to see Sara again.

Three times he has seen her, or rather in three phases: first her body, then her face, and finally in the flesh, a little animal with stormy-coloured eyes, so vulnerable, fearful, and yet untamed, rebellious.

Sara has run away. She no longer feels safe in her own room, anywhere. She no longer trusts her parents, they failed to protect her, to keep these strangers away from her. Where did that boy come from? What did he want? Why did he keep repeating, 'It's you,' in that absurd way? You? The sorceress, the wreaker of havoc, the pariah, the killer?

She makes her escape along the beach, her face half-shrouded in a long, flaming-red silk scarf that she grabbed from the hall where it was lying on a chest. She rushes to seek refuge in a wooden cabin perched above the water, the fishing hut above Meschers that her father owns. No one will think of looking for her there, she says to herself.

'Let's go for a little stroll along the cliff while it's still light,' suggests Raphael, 'it's good to build up your reserves of light before braving the dark.'

The dog rushes about hither and thither, sometimes he comes up to them to solicit a pat, then he is off again, yapping joyfully. But suddenly his pace slackens, he sniffs at something in the wind, veers off and heads towards a fishing deck, and crouches in front of the gate leading to the walkway. Tobias continues on his way without noticing that the dog has stopped.

'Your dog has given us the slip,' Raphael says eventually.

'Where's he gone?'

'Over there, he has taken up guard at the entrance to that fishing deck.'

Tobias calls, whistles, but the dog does not stir or even look in his direction.

'What on earth has got into him?' says Tobias in irritation.

'He's waiting for you. Dogs don't do anything without a reason.'

'And I'm waiting for him! And I don't see what reason he might have to mount guard outside a deserted hut!'

Tobias has no sooner completed his last sentence than

Raphael seizes him by the shoulders and gives him a good shaking, and he has some harsh words for him.

'If dogs don't do anything without a reason it's because they're good at sensing things, which isn't true in your case. Is your heart so sluggish that it doesn't leap when it passes close to the one you just happen to have fallen in love with? It's not enough to get drunk and glutted on images, you have to improve your sight until you can see in the absence of proof or tokens of evidence, see into the hidden depths of the visible, read and feel the invisible. You don't yet love her if you can't see beyond the limits of the visible, if you don't perceive the whisperings and sighs of silence, if your hands don't know how to touch the other even at a distance, to embrace her in her absence. No, you don't yet love her.'

And Raphael pushes him away.

Tobias stands there speechless for a moment, bewildered by this unexpected attack, and above all cut to the quick by words that have come like a slap in the face. He gradually sorts out his thoughts, and far from being angry, he realizes how much truth there is in what Raphael has said.

'What should I do?' he asks.

'Don't miss your chance. You remember the tenth commandment that I was telling you about the other day?'

'Yes, "You shall not covet your neighbour's goods."'

'Correct, but that doesn't mean you shouldn't be bold when the moment is ripe for you to take in hand your destiny, to seize your chance. The opposite, or rather the extension of that dictum, is that we need to be able to recognize what belongs to us, what it is our right and responsibility to make our own, without depriving anyone, without idly imitating other people either.'

'But Sara doesn't want anyone to come near her. How can I get close to her without terrifying her once again, without provoking catastrophe?'

'Go to her, without apprehension, fear, or impatience.

Don't make any demands on her, be as gentle as you can, arm yourself with calmness and trust. Have no desire for anything but Sara's deliverance. Drive out the fear that has taken hold of her body and soul, dispel the seven spectres that haunt her, enjoin silence and light on her.'

'Your advice sounds great,' Tobias concedes, 'but what use will your fine speech be when I'm standing in front of her and she doesn't hear or see anything but her menacing spectres howling with anger. All words will be pointless . . .'

'Do you have so little faith in the power of words, then?' Raphael cuts in. 'Have you forgotten those poems you used to read and learn by heart when you were a child? And what is Sara's illness if not a great welter of accusatory words that deafen her day and night? It's your task to silence that incessant uproar inside her. Besides, I've given you the key to open the door of her frenzy, the time has come to use it.'

'What key?'

'The tongue and heart of the fish we caught on the first day, which I gave you to keep. When you enter the hut, throw them on the ground at once, so that the silence instilled in them wells up and spreads out. Wait a few moments before crossing the threshold; you must let the place fill with silence, let it penetrate everything deeply. Then, it's up to you to find the right words to secure the reconquered light. Go now, and do as I've told you.'

Tobias makes for the fishing deck, he clutches in his hand the box containing the fish's heart and tongue. The dream that burned brightly within him a little while ago and set his flesh, his heart and his imagination dancing, gives an ever greater lift to reality, like a wave gathering amplitude, impetus and increasing transparency. As the dream distills, it becomes more intense, and casts a new light on reality.

Tobias has a sense of walking ahead of himself. Today it is not the shadow of his childhood that trembles and flees at his

every step, it is a new unknown force that carries him along and draws him towards the open sea. He feels purged of all shadow, unshackled.

The dog has not budged. He merely raises his head when his master passes and follows him with his eyes for a moment. Tobias sets off along the walkway. A powerful wind blows and whistles all around. He opens the door of the hut. Sara, who is leaning on her elbows at the window looking out over the estuary, whirls round and straightens up. She sees in the doorway the same stranger who came bursting into her room a few hours earlier, and her terror becomes acute, all her wits and resources are thrown off balance. But before she can utter a word, a cry, Tobias throws on the floor the conger eel's heart and tongue. And at once fear and madness are dashed; the shrill cry that was about to break out falls back into silence. A silence that tinkles and gleams in the already deep blue of the evening.

The wind drops, matches the breathing pattern of the two young people standing face to face in the timber hut suspended over the seashore, on the fringe of night. Slowly, very slowly, a smile appears on Sara's lips. Tobias smiles back, and walks towards her. At that moment he is carried on the crest of the wave in which dream and reality are churned up together – a wave born nearly twenty years ago, which has long remained dormant in the solitude of the marshes, then started moving, sweeping along the shoreline.

Meanwhile Edna and Ragouel look everywhere for their daughter. They eventually go outside, comb the beach, peer into the caves.

'Let's go and see if she hasn't taken refuge in the fishing hut,' suggests Edna.

They meet Raphael on the way. He greets them and mentions in passing that his friend has stayed behind, over by the fishing huts, then he takes leave of them and walks off. The

anxiety of Sara's parents increases with every step they take, it chills them when they reach the gate to the walkway where the dog, which they recognize, is still mounting guard.

'Let's not go any further, Edna! If there's been another calamity Sara will surely have returned to the house, or fled elsewhere. Let's go back. I'll come out again later, when it's completely dark, and the tide is up. If that boy's dead, I'll lower his body in the net, load it into the boat, and go and dump it at sea, so no one will know that another tragedy has taken place. People will think he's gone elsewhere. Come on!'

And they hurry away from the place.

SIGHT RESTORED

When Tobit saw his son, he threw his arms
around him and wept. He exclaimed, 'I can see
you, son, the light of my eyes!'

The Book of Tobit 11: 13–14

Darkness spreads over the marshes, the colour of onyx. The peacock is dead, but the cracked sound of his harsh and plaintive cry still breaks the nocturnal silence now and then. The voices of the people and creatures we have loved are like smells: they endure beyond the disappearance of the body that gave them utterance, that exuded them. The peacock's cry hangs about the house just as the smell of wisteria long lingered beneath the untended pergola frequented by lovers that was left to run wild. So many echoes linger too in Theodore's heart, so many vestiges still alive and trembling.

He rests his forehead on the window. But it is not his reflection that appears, but the memory of Anna. He sees – a mist, no more – the pure oval of her face, her black and shining eyes, her grave mouth. He has no more tears to shed, nothing but a grief that never ends, insane in its persistence and fidelity.

He opens the window, puts his forehead to the darkness and is amazed that the darkness does not give way, does not even yield beneath the weight of his sorrow. A few stars in the distant heavens shine with a weak, cold light. If only one of them could detach itself, fall through the vastness of space, and land in the middle of his forehead so that his captivity should finally end. His capitivity not in the land of the living, but in a land of absence. Or else if one of them could fall on the spot where Anna's head lies, reveal to him the place for which he has been doggedly searching for the past fifteen years. The body in the tomb remains mutilated; Theodore dearly wishes that it might be granted to him to find her head and restore it to the body before the hour of his own death. He scans the night sky, seeking some sign, but not a single star moves out of place and the coldness of their light steals into his flesh. He

closes the window, turns to lie down on the sofa, although he knows that sleep will not come. All that consoles him is the prospect of Tobias's imminent return. It is already nearly a week since his son left, and loneliness weighs more heavily on him than ever.

Darkness spreads over the marshes, in its potency and calm. Arthur is dead, all his cries, oaths, threats are silenced for ever. Valentine is at peace. She is at peace with the world, with herself, with her memory of Arthur.

But she is not yet dealing with a memory, rather a thought. For she thinks of him with concern, with great compassion. Violent as he was, he has died the way he lived, in a blaze of cries, of madness. In total disarray. She strives mentally to accompany him on his brutal entrance into the abode of the dead, on his infinite journey. She would like to be able to help him, to guide him, to silence in him that terrible tumult which deafened his adult life, spelled the ruin of his heart, blighted his love; for she suspects that such a tumult, far from ceasing at the moment of death, must go on and on, and torment the disincarnate body more than ever.

Does he hear her voice at last, as she lives on, taken up with dreaming and silence? Does he see the light at last? Does he hear the heartbeat of his wife who now feels a sisterly tenderness towards him? Does he now understand the mystery and power of love?

She walks outside the door of the house, lifts her face to the sky. She offers her face up to the darkness. A few pale stars shine through in the distance. She raises her brow, her hands towards the stars. She hopes to increase their brilliance, make them reel, dance, send them as messengers to Arthur. To convey her forgiveness and her request for forgiveness. For she well knows that he was not the only one at fault; he bore within him an anger of which he was not at all the master but the slave, and she failed to free him of it, to relieve him of the

fury that seethed inside him. She should have rebelled; all she did was fade away beside him as the years passed. Just as he had consigned her to fear and solitude, she left him as much alone and helpless. By consenting to become a victim, she made herself an accomplice to the obscure evil that haunted him. They suffered desperate unhappiness, on either side, each of them aggravating the other's distress. It is time, now all that is over, to share forgiveness and consolation.

Standing in the doorway, she sings. She sings under her breath, as she did the evening she ate the cake of the dead with the four invisible women. She prays to these women to look after Arthur, to lead him on the path of disintegration into silence and light. The path she glimpsed in a dream, in the depths of her memory, when she journeyed in the uplands.

But suddenly she feels oppressed and her voice fails; just in front of her is a large mass, lurking in the dark like some enormous beast, all the more dangerous for being wounded. It is the furnace building, the sound box of Arthur's madness. A beast of stone and brick with entrails of ash, shattered glass and dust, a beast that once was full of yelling and hatred, but now is starving, run to ground by its own anger turned against itself, a beast that snarls, with low growls, challenging the song of conciliation. Valentine hurries back inside her house.

Darkness looms over the estuary, quietly moaning. Is the young man called Tobias dead like the other seven? Has he dared approach Sara, hold her and embrace her?

A boat glides through the darkness. Edna sits huddled in it, Ragouel rows without making a sound. They hold their breath, avoid meeting each other's eye. Among the countless other stories the mouth of the estuary keeps churning over, again and again, is it shortly going to swallow up another casualty and recount Sara's dark tale to the rhythm of its tides?

Ragouel lands on the beach, pushes the boat back out, asks Edna to go and wait for him beneath the net. Ragouel

scrambles up to the walkway. The dog is sleeping by the gate; he does not wake, does not even stir as Ragouel passes. 'Is the dog dead too?' Ragouel wonders, increasingly worried. He walks round the hut, checks that Edna is at her post. The boat and the net are bobbing gently, one directly below the other. He finally goes up to the hut, opens the door very cautiously.

He has been expecting the worst, and at first he thinks he has seen the worst. Two bodies are lying on the ground, so closely entwined that Ragouel cannot immediately tell which is his daughter. They are both naked, their hair entangled; two heads of dishevelled black hair on a dark red background, which Ragouel thinks is blood, blood flowing from these two heads. He bends down, touches the hair, the red stain. The stain is dry, as silky as the hair; it is only a scarf laid beneath the sleepers' heads.

For they are sleeping, a deep, peaceful sleep. Ragouel hears the quiet sound of their breathing. He touches each sleeper's shoulder; a gentle warmth emanates from their skin. With his fingertips he lifts the black curls covering the faces. The sleepers are lying forehead to forehead, their profiles mirroring each other, the brightness of one suffuses the other's face, the smile of one is reflected on the other's lips.

Ragouel straightens up, and finally realizes that the milky light that illuminates the two bodies in the midst of the darkness does not come from the handful of stars scattered in the sky, but from no other source than the bodies themselves, and the silence that fills the place, like an interval in the midst of the surging waters and the moaning of the wind, rises from their sleep. Ragouel does not seek to penetrate these mysteries any further. He contemplates the couple curled up in their own light, in the intimacy of absolute silence, and beauty reveals itself to him in an expected, undreamt-of guise. He is visited with happiness such as he has never before experienced, even in the throes of lovemaking, at the height of passion, or in the act of painting, a happiness that throws into

confusion his vision of the world, of time. He bends down again, strokes his child's hair tangled with that of this second child that has just been given to him, and he leaves them, taking care not to disturb their sleep, their communion in sleep.

He steps off the walkway, goes down to the beach, signals to Edna. The boat slowly approaches.

'Come,' he says to his wife, 'let's leave the boat here and walk home.'

'Where's Sara? What's happening up there?'

'What's happening up there is a sweet miracle of beauty. Our daughter is alive, and Tobias too. They have been celebrating the rites of an oceanic wedding. And there we were, preparing a tomb in the trough of the waves, like two criminals!'

He bursts out laughing, grabs Edna by the hand and goes running over the rocks, dragging her after him. Edna tries to hold him back, she asks him questions. He stops for a moment, lays his hand on his wife's lips.

'Be quiet, don't try to understand everything too quickly, or you won't appreciate the wonder and surprise.' Then he takes off again with his wife in tow.

Darkness rests upon the estuary, so very transitory. A pause in eternity. Raphael is sitting on the edge of the supporting wall around the church of St Radegund of Talmont. The water laps at his feet. He knows that tonight death has been averted, vanquished: over there, in a ramshackle hut perched in space, the desire of two people has been fulfilled, and this desire will continue to grow. At this very moment, all over the world, men, women and children, of all ages, are dying. They are dying in distress, and rebellion, and suffering, or acquiescently. And as they draw their last breath, new individuals are born who know nothing yet, who arrive all bathed in forgetfulness and freedom from care but who will soon be burdened with

trials, tribulations and hopes, and in their turn will have to endure the glories and pangs of desire. But he himself is beyond memory and forgetfulness, beyond fear and desire, where love, wisdom and the simplicity of love burn brightest. He watches, he ponders. He has not yet come to the end of his journey. He thinks about that old man, Tobias's father, in the reclusion of his bereavement, mantled with grief, awaiting his deliverance. The hour of his release is near.

The estuary rests in darkness. Raphael looks up at the sky. He identifies myriads of stars, knows each one by name. They too are born and die, each has its history, its conflagration, its trajectory, its dying throes, just like human beings. But human beings have such great need of messengers, without whom they do not succeed in receiving news from their own hearts, in sorting out the tangled threads of their destiny. They are like the moon, which appears beneath a veil of grey clouds; the light they manage to cast does not come from them alone, it originates from a much more distant source, and everyone reflects it with greater or lesser intensity and bountifulness, depending on each one's purity and patience of heart.

A man's destiny. There is nothing more absurd, more wonderful. Raphael balances in his hands lying open in his lap the weight of this absurdity and of this incredible wonder. He does not come down on either side, the scale finds its own level. Every destiny is the weight of a feather, and yet as heavy as the world. And at any moment every destiny can tip to the side of lightness and transparency, or that of heaviness and opacity.

Raphael probes the darkness, with his eyes and ears, with all his senses, with all his heart.

'The heavens declare the glory of God, and the firmament proclaims his handiwork. Day pours out the word to day, and night to night imparts knowledge.'

How right is the psalm, but to how many on earth is it

granted truly to understand such a message, to be able to listen to it, to know how to read it?

'Not a word nor a discourse whose voice is not heard; Through all the earth their voice resounds, and to the ends of the world, their message.'

So many deletions, torn pages and blots destroy the readability of this text of pure transparency, distort its meaning. How could men fail to be constantly prey to doubt, to anxiety?

When the sky begins to lighten, Raphael leaves the headland, and wanders along streets lined with hollyhocks and silence.

During the morning he meets up again with Tobias in the cave where they slept the previous night. Tobias does not say anything, he is listening to the song rippling beneath his skin, flowing in his blood, surging in his flesh; a song of delight, of ineffable happiness. He feels as if he has just been born a second time, that his body has been reintroduced into the world. A new body, so much more alive and sensitive than the old one. He has emerged from the limbo of the past, from the grey torpors of melancholy.

Raphael asks no questions. He lets his companion carry on in a waking state the dazzling dream he had during the night in joining with Sara, then sleeping entwined with her. They both fell into the deepest sleep, that original sleep that brought forth Eve from Adam's side, and that Adam found in Eve's embrace. From such a sleep one wakes transformed, extremely altered, and at first light the spirit is amazed by this radiant renaissance, this metamorphosis of the flesh and the heart. It takes time to realize the extent of the change that has occurred within oneself, to scan the expanse of one's new inner spaces, spaces that remained unsuspected until that coming together, that union and consummation of pleasure.

After a long period of silence Raphael lays his hand on Tobias's shoulder and says: 'I'll go to Bordeaux on my own to take care of those things your father asked you to do, just let me have the documents he gave you. You stay here with Sara. You've saved her from her fears, but she's also saved you from your anxieties. You're both even with each other and indebted to each other. Now your task is to build something on that trade-off, to make sure that this ever unstable, ever precarious, mutual give and take lasts and flourishes. Her parents will welcome you like a son for having rescued their daughter. Go to their house, your place is with Sara. I'll come and pick you up in two or three days from now, and we'll go home to your father, he must be starting to worry. It's time to help him find peace, he too is awaiting deliverance.'

And Raphael sets off for Bordeaux while Tobias goes to rejoin Sara.

A few days later Raphael and Tobias are back in the marshlands. As they pass near the cemetery, Tobias slows down, he feels a desire to go and spend a quiet moment before the graves of his mother and Deborah.

Creeping plants with lanceolate leaves of a still delicate green zigzag across the mound beneath which Anna's body lies. A rose bush with yellow flowers veined with orange has been planted at the edge of the mound. Even under the earth her headless corpse continues to be transformed into roses, the way she appeared to Theodore fifteen years ago. Tobias is amazed by the presence of this rose bush and wonders who on earth planted it, since he is sure it could not have been his father who obstinately refuses to visit the cemetery. And a similar surprise awaits him in front of Deborah's tomb. The voluminous heads of bright yellow sunflowers stand at the head of the stone slab that has turned dark grey with the passage of time. Even under the earth old Deborah continues to question the invisible indirectly, through these plants that

all day twist their sturdy stems in order to maintain a constant and silent face to face relationship with the sun.

'Can someone go up to heaven and ask God if is this way things should be?'

It is years since Deborah went up to heaven, but the question that ran all through her life, without ever failing or flagging, remains there, inveterate and stubborn, rooted in the earth of the living and the dead.

Yet another surprise turns up, and stops Tobias in his tracks; as he is on his way out he notices alongside the path, at the end of a row of graves, a stone on which are inscribed the name of Arthur Lambrouste and his dates of birth and death. So it is that he learns of the very recent demise of the uncle he scarcely knew, who had long inspired him with nothing but fear and mistrust.

But he knows nothing of the circumstances of his death, or of Valentine's sudden recovery. And he has no inkling that it is she who has planted the rose bush and the sunflowers.

As it happens, Valentine is with Theodore when Tobias finally arrives, accompanied by Raphael. Now she likes to go out, she even feels more at ease away from home. Towards evening, something oppresses her in that house hemmed in by the kiln and the shed, as if Arthur's ghost was still prowling round over there, full of surliness and distress. She intends to move into Deborah's empty house and, not wanting to live there any more, put her own up for sale.

Tobias recounts his journey to his father and tells him that the loan he made will soon be repaid. He tells him too about their visit to Ragouel and his meeting with Sara, who will be coming shortly, but he does not speak about the dismal legend that caused the young girl grief. It is not that Tobias takes too lightly this dark side of things, he only wants to relieve the present of the burden of the past, and he would so dearly like this too for his father.

The next day, as they are walking alongside a stream, Raphael says to Tobias that it is time for him to be on his way.

'I'm leaving tomorrow.'

Tobias has been dreading the moment when his friend would leave, especially as he suspects he will not see him again for a very long time, perhaps never. Raphael came into his life unexpectedly and, without appearing to do anything, has changed it completely. He is going to take himself off in a similar manner, travelling at the mercy of the wind and the light, when and where he stops depending on the charm of places and whom he chances to meet. At the same time Tobias senses that it is not really a question of chance, or at least that Raphael has the art of imparting to apparently fortuitous events a stamp of urgency and necessity, and above all a dual aspect of mystery and straightforwardness at one and the same time. He wishes Rapahel would extend his stay, but he knows that it is impossible to hold back such a wanderer.

'I shall miss you,' is all he says, not daring to give any greater expression to his sorrow, his regret.

'I shan't forget you,' replies Raphael, 'I don't forget any of the people I meet and become friends with. Friendship is a wonderful kind of love, unravaged by the frenzies of jealousy, of possessiveness or the will to dominate, it's all light and shade and subtlety. A passionate love without friendship has very little chance of surviving . . . But what's that tower over there?'

'That's not a tower, it's the chimney of the big kiln.'

'The brick kiln that your aunt mentioned? I'd like to take a look at it before I go.'

Valentine is not at home, and Raphael and Tobias wander round the outside of the house. In the shed are sheets and pillowcases hanging out on a clothes-line.

'The other building is bound to be locked,' says Tobias. 'Arthur did not let anyone go in, he guarded his territory

ferociously, like a dog ready to bite. It must be in a woeful state inside.'

'Let's go and take a look anyway.'

The door is indeed locked, but Raphael picks up a length of wire and deftly twists the end of it, slips this improvised key into the lock and skilfully fiddles with it for a moment.

'There we are, that wasn't so difficult. Arthur's precautions were not very impressive!'

And with that, he enters the building. Tobias reluctantly follows him.

It is dark in Arthur's den, with a strong smell of dust in the air. The dog sniffs in all directions and growls steadily for he detects many more scents than the mere smell of dust – cats, small rodents, birds, bats have been through here or are crouched in the corners. But Raphael bends down and in a swift motion lightly touches the dog's nose. The dog immediately changes its attitude and runs over to stand in front of one of the oven doors, and there begins to howl, with a prolonged, very high-pitched sound.

'What on earth is the matter with him?' says Tobias. 'I've never heard him howl like that before. This place is really creepy, let's go.'

'And what if he were sending you a message again, as he did on the beach the other day? Have you already forgotten, then, that dogs don't do anything without a good reason?'

Tobias does not dare contradict his friend, but he is not very convinced; he crouches down beside the animal, strokes his head and tries to calm him, principally to lead him away. The ground is strewn with broken glass, he is afraid the dog might hurt himself, but the dog refuses to budge. So he gently picks the dog up in his arms and holds him to his chest. Tobias only half turns to go; he does not do anything but he does not leave either. He waits, without knowing exactly what for. He feels an obscure unease, the dog's strange agitation passing on to him, his accelerated heartbeats thumping in his chest. He does

not really know whether the behaviour.of dogs is always motivated by a precise cause. What he has realized, however, is that Raphael never intervenes without reason, and that is why he prefers to let him take in hand the development of events.

Raphael has sensed Tobias's helplessness, so he in turn comes over and without a word, acting confidently, he forces open the metal plate over the mouth of the oven.

The face is sharp, the nose pinched at the end, the skin ochre and bister coloured. The eyes are still open, just a slit between the eyelids, like someone concentrating on a thought, a doubt. The lips are cracked, forming a curious lace around the teeth. The hair is luxuriant, of shiny black.

When Raphael takes the head out of the niche in which it had been locked away, the hair tumbles loose with a quiet swish, falling right down to the ground. The face seems even more tiny in the middle of this streaming black hair.

Tobias stares, squeezing the dog very tightly in his arms. He looks at what his father has never seen: the part missing from the body of the rider who went galloping straight to her death. The part responsible for his father's madness, for the sclerosis of his grief. He stares at the tiny face lost in the blackness of its extraordinary hair. And once again he is reeling, no longer on familiar ground: time has stopped and the visible world is in flux. But no bedazzlement on this occasion, and no vistas of shifting, fluid, shimmering spaces as when he came face to face with Sara. No, this time there is only an abrupt confrontation with darkness.

His mother's face is exhibited before him, her eyelids lowered, her mouth fringed with adamant, unfathomable silence.

'Mother, I'm no good at looking for the dead . . .'

And yet here she is, found again, more cruelly dead than when she disappeared and was still being sought.

'I was you, so powerfully once, and now so feebly,
And the two of us so inseparable we should have died together
. . .'

But they did not perish together, neither father nor son.
Anna went alone, stealing from each of them a great chunk of
their heart.

'You have no need of a heart any more
You live apart from yourself, as if you were your own sister
. . .'

Apart from her nearest and dearest, apart from herself, and
even from her own body, long since rotted in the earth, his
mother is infinitely isolated, solitary. Will she be less so now?
Is it enough that she reappear to cease being a stranger to
herself? But is it not rather to him, her son, that she has
become a stranger? So close, and unfamiliar.

Tobias sets the dog down on the ground away from the shards
of glass. He bends down, gathers together the hair and slowly
rolls it up.

'Hold it like that,' he says to Raphael, 'I'll be right back.'

He goes out. The afternoon light bruises his eyes as if he
had been in the dark for a long time. He goes over to the shed,
takes a pillowcase from the washing-line, folds it up and carries
it away. He rejoins Raphael, wraps the head in the pillowcase
and, clutching this bundle like a babe-in-arms, he leaves
Arthur's den.

'Let's go home now, my father's been waiting long
enough.'

It was a lovely day, dust catching the sunlight among the
leaves. But suddenly it was so much lovelier. For horror can
come close to beauty, especially to eyes sharpened by hatred.

Arthur had just started down the shaded avenue when he caught sight of a round black object in the middle of the road. He thought it was a ball that some kids had lost. He picked it up and for a moment he thought he was hallucinating. Anna's head, with her riding hat on, had been lying in the mud, ringed with a pool of blood. The slender oval of her eyes still glistened between her eyelashes. He looked round, noticed the hoofprints on the ground and spotted the dislodged arch-support, and the thin wire that was red in the middle. So it was not an hallucination, but indeed the head of Miss High and Mighty.

'What a master stroke of luck, a gift of fate!' Arthur said to himself with wonder, and he tucked that bloody gift under his jacket and hurried home with it.

With what acrimonious joy did he burst into the house and shout to Valentine who was sitting by the window, busy sewing up the hem of a blouse, 'The lovely lass has killed herself riding her horse down Lovers Lane, popped her head off like a champagne cork!' Then he gave an ill-tempered laugh. Valentine looked at him without really understanding, she thought he was already drunk, that he was raving. Then he added, half-choking with laughter, 'You see, Tine, you're both the same now, the tall lass has lost her noodle, just like you! But she's gone and lost it with a vengeance!' And with those words he rooted out from under his jacket the head wearing its riding hat, and brandished it before Valentine's bewildered eyes. 'Take a good look, Tine, look, I wasn't lying! So, what have you got to say?'

She said nothing, she leapt to her feet, overturning her chair, the blouse, the sewing basket, she backed away, knocking into the furniture, then collapsed under the sink, her hands pressed to her face, uttering cries that sounded like mewling.

When she dared to remove her hands from her eyes, Arthur had disappeared. Traces of blood stained the tiles; she grabbed the floorcloth and, still whimpering, on all fours, she scrubbed

the floor. And the more she scrubbed and scraped and cleaned, the more she effaced the reality of that vision. But it addled her wits, and it was fifteen years that she was to languish in that benighted state. And though she finally recovered her sanity, nevertheless Valentine did not regain consciousness of that scene, the memory remained sealed, banished, denied.

Satisfied with the effect he had produced, Arthur turned on his heels, leaving Valentine huddled under the sink, and went into his palace of dead fires. He removed the riding hat, freeing the long hair. Anna was now his, and under his power, an object. She was his possession, his secret, his revenge against Theodore whom he had always envied. And Valentine too was going to belong to him more than ever before. A mummy and a puppet! For such were his plans for the dead woman and the poor simpleton, they were to be reduced to that. He cleaned one of the ovens, placed the head in it, and carefully sealed it up.

For years he left that funerary alcove closed up; the head had to dry out. He contented himself with shouting insults and curses at it, breaking bottles against the oven door. So his furious nocturnal monologue with Anna – that black ember keeping watch in the empty hearth – had gone on. He had not opened it again until the day Valentine ran away.

'Ah, at least you're still here!' The head was light, but the hair was heavy, it seemed to have grown longer and thicker to the most extraordinary degree over all those years. 'Is it because you had nothing to eat but the dark that you've grown this mare's mane? Tell me, it's the dark growing out of your head, is it?' And he put the head on his lap, tidied its hair, dusted it. He confused Valentine, Anna and himself with this hair. 'You look as lovely as you did the first day . . . ' he exclaimed after a moment, not really knowing whom he was addressing. But his rush of tenderness was of short duration,

he put the head back in its niche, and slammed the door, shouting, 'Go back and feed on the shadows, you lousy slut!' And he began to drink.

Then for the last time his distress exploded in rage, he bellowed his resentment, his grudges, proclaimed his perverted love, swearing. 'Damn you, horse-face, and damn you, Tine, you bitch! And the whole world, the entire planet should be thrown in the bin! Damn God! None of you showed me any pity. It's all a lot of lies, rubbish, and betrayal . . . What? What did you say? Who's speaking? Is it you, Tine? You snake, where have you wriggled off to? I'll kick you, punch you, throw bottles at you . . . here, take that in your face! Ah, some music!

'Pinheads, I hear you sniggering, and you, God, I know that hyena-like silence of yours, but I'll make you sing! Hey there, some music! I've got a reeling and a thumping inside my head, blasted Tine, it's you running between my temples, stop, give us a break . . . Damn all women, my mother for a start – who asked you to bring me into the world, eh? Not me, no way! You bunch of sows, with your saintly airs and your love potions . . . and you, God, are you by any chance a woman? They're the ones that keep this rotten life going, but who's behind this whole mess, if not you? Who's that speaking? No, there's no one there. There never is. Only pinheads. Anna, you witch, will you stop grinding your rotten teeth, drilling into my head . . . and just you wait, Tine, I'm going to give you such a thrashing . . . hey, some music!' And he smashed a bottle against the oven every time he called for music. But he went on so long wrestling with phantoms that he toppled from his high chair and tumbled to the ground amid the broken glass and spittle.

Tobias immediately withdrew after handing his father the mummified head. Theodore said to him, 'Leave us together.' He wants to be alone with the relic of his beloved.

He takes her in his hands, examines her closely, in silence, then presses his forehead to that of the dead woman, closing his eyes, and remains like that for an indefinite while. Two ilex locked in absolute motionless combat. At last he lifts his face and, contemplating the face like a russia leather mask, he speaks to Anna:

'So here you are, I've been waiting for you, hoping for you, for so long, my young dead wife, beloved now as on the very first day ... After endless searching, calling and entreaty, here you are in front of me. For you I went out of mind, lost all taste for life, all hope, I was cast into hell by your absence. The world was a desert, and every moment a torment. But you've reappeared, lighting the desert, loosing the knots of time. The scorching tears and desolation are over now. The peacock's dead, worn out by wailing, by the incantation of its own solitude, at last its cries are silenced within me. Still remaining are the gold and turquoise eyes with which its plumes are studded, a luminous shower in the blue shadows of night. Surely it's you who give them their brilliance of aspect! The night is celebrating, it dances with the day, reconciles sun and moon, earth and sky, the living and the dead.

'An ocellated night illuminates the world, the invisible is in blossom, the visible in splendour and all flesh quivers. Smell that! The night exudes an odour of sap, fern and wind, an odour of sea, bark, flame and stone . . . It's your parting breath that embalms the world with a bitter sweet fragrance, which revives it . . . Your face restores my heart. Don't turn away, don't leave me again.

'Hear how this new heart rings, this second heart that beats only with joy at seeing you again, and also with impatience to lie down beside you. Our bed is of clay, it is deep and enclosed, but we'll dig it yet deeper till we burst through the earth and tumble into the open sky. Then we'll drift above clouds and snows, we'll fly where the stellar winds carry us,

we'll swim in the stream of the Milky Way, we'll trace it to its source.

'Having completed this migration before me, you can show me the way, and I'll wear you on my heart like a streak of dawn. Feel! My heart is already turning to clay and taking on the twinkling colours of the stars . . .'

FAREWELL LAUGHTER

'As for me, when I came to you it was not out of any favour on my part, but because it was God's will. So continue to thank him every day; praise him with song . . . Behold, I am about to ascend to him who sent me; write down all these things that have happened to you.'

The Book of Tobit 12: 18 and 20

Tobias is taking a stroll with his companion for the last time. As they walk, Raphael throws a piece of wood far ahead of him and the dog takes off barking, jumps up to catch it in the air, then returns with the stick between its teeth. He drops it at Raphael's feet and waits with frantic excitement for the game to be repeated.

A half-charred boat lies in the grass by the edge of a stream. The remains of a chair and a few tatters of cloth can be made out among the debris. Tobias halts, gazes at the blackened carcass, and a blaze of anger flares inside him.

'Arthur's boat! That brute did nothing but cause havoc, destruction and suffering, inventing vile hellish scenarios right up to the very end! Breaking, burning, bad-mouthing and cursing, stealing . . .'

Raphael gently interrupted him, laying his hand on his shoulder. 'What's the good of getting worked up, harbouring bitterness and resentment, and what right have you to judge and condemn? Did that man not condemn himself, with a violence equal to his distress? So why worsen his suffering?'

'He worsened my father's to the point of madness, didn't he? He profaned the body of a dead woman, didn't he? Where's the sense in that?'

'There's never any sense in evil, only stupidity. Come on, leave this derelict boat here to rot, and leave your anger with it.'

The dog comes racing back, its eyes shining with excitement, biting hard on his catch, and growling to get a better rise out of his playmate, inciting him to a tussle; he backs away, jumping, in front of Raphael, who takes up the challenge, pulls the stick from the animal's jaw and throws it so far that it disappears into the little wood on the other side of the stream.

Raphael bursts into loud laughter as he watches the dog go dashing after its wooden prey; then he suddenly turns to Tobias and announces: 'It's time for me to leave. Let's part here, without any fuss . . .'

He hugs Tobias, kisses him, and walks off without a backward glance.

Tobias is left speechless so abrupt is this departure, and above all it is the casualness of it that disconcerts him. He still had so many questions he would like to have asked Raphael, so many to things to say to him; he would like to call out to him, but reticence prevents him. He just takes a few hesitant steps and it is then that he notices that the shadow cast on the path by Raphael is not grey, it stretches out, thin and golden, like a ray of light filtering through the leaves of a lime tree in the spring.

The dog comes racing back, proud of having found the stick, but in the wink of an eye Raphael is gone. The dog nevertheless runs towards the place where he was walking, goes round in circles, sniffing along the ray of golden shadow trembling on the ground. Tobias comes up to him, crouches down beside him; he touches with his fingertips the luminous strand quivering on the path and he feels in the very heart of his sadness a confused inexplicable joy.

A lighted window shines in the evening, with music abounding. Through the window two figures can be seen spinning round. A couple is dancing a lively-paced, light-footed waltz.

They are not man and wife, but father and son. One of them wears a black suit with silk braids and facing, and an immaculately white shirt, while the other is dressed in faded blue jeans and a red tee shirt. Their faces reflect the light which illuminates the drawing room, but even more so the light of the marshland skies, of slow waters, of dreams.

When Tobias came home at twilight he saw the windows of

the ground floor all brightly lit up. A waltz tune filled the house. And when he opened the drawing room door he remained on the threshold for a moment, rooted to the spot with surprise. His father was standing in the middle of the room, dressed with an elegance he had never seen in him before.

'Come in, son,' said Theodore, smiling, 'I was waiting for you. This is an evening of celebration and greetings. Every New Year, and on every birthday of each of the three of us, I used to dance a waltz with your mother. We're both going to dance this waltz in honour of her, then we'll dance in Sara's honour, and your friend Raphael's. And we'll also dance to the memory of Deborah, Rosa, Wioletka . . . ' And with a supple and commanding gesture he took Tobias in his arms, and led him into a fabulous whirl.

It took Tobias a while to regain his presence of mind. Then he felt a sense of shame, so horribly grotesque did the situation seem to him, as when he was a child and his half-paralysed father smothered him with his pitiful caresses. But almost at once this sense of shame died away. It was unjustified.

He lets his father lead the dance. The waltzes succeed one another, sometimes slow, sometimes lively, and Tobias gradually feels himself carried off into the margins of time. It is with Theodore that he spins round, but also with his mother, with Raphael, Sara, Deborah, with the silent meditative crowd of his ancestors. And also with Arthur, boorish brutal Arthur, who died dancing in a similar way, with a phantom of love on a boat in flames. He dances with each one, the meek and the humble, the living and the dead, and his head is spinning and he feels a weird tingling in his heart.

Tobias offers himself for the last time as a substitute, the embodiment of total compassion; not to be fought against any more, his father is no longer at war with the world, he has surrendered his arms. Tobias has realized that Theodore is

dispensing his farewells to the world by dancing himself dizzy, becoming more light-headed and radiant with every new waltz. He rests his cheek on his father's shoulder, and laughs. He laughs to dispel any desire to cry, to weep, to judge. He laughs to the rhythm of the dance, with verve and grace.

And his laughter goes flying off in the dark to a scintillating waltz tune, it whirls round on the face of the sky to ask God if this is really the way things should be. And the sunflowers planted on Deborah's grave shed their petals like so many question marks in the night wind.